IMAGES
of America

MILTON

IMAGES
of America

MILTON

Doug Welch and the
Milton Historical Society

ARCADIA
PUBLISHING

Published by Arcadia Publishing
Charleston, South Carolina

Printed in the United States of America

Library of Congress Control Number: 2015949515

For all general information, please contact Arcadia Publishing:
Telephone 843-853-2070
Fax 843-853-0044
E-mail sales@arcadiapublishing.com
For customer service and orders:
Toll-Free 1-888-313-2665

Visit us on the Internet at www.arcadiapublishing.com

This book is dedicated to Harvey Johnson, a man who never met a photograph of Milton he did not like—or collect. This work is also for his children, Paul Johnson and Polly Jones, who helped make this book possible through their thoughtful and caring donation of their father's extensive collection to the Milton Historical Society.

CONTENTS

ACKNOWLEDGMENTS

The driving force behind this book is the Milton Historical Society, which traces its roots to a 1938 committee charged with planning a centennial celebration commemorating the founding of our community. When the society purchased the Milton House property in 1948, it began serious and constructive collection, archiving, and preservation of Milton's rich history. That effort continues today with the publication of this book, thanks to the support of the more than 400 members of the Milton Historical Society. This effort was enriched by the contributions of the Milton College Preservation Society. All of the photographs in this book were mined from the archives of these two dedicated organizations. Special thanks also to Judy Scheehle, Rod Hilton, and Mathew Holly for lending extra expert eyes on the project. A very special appreciation to the members of the Milton Historical Society board of directors and former executive director Cori Olson for their support of this project. Finally, the entire Milton community wishes to thank Arcadia Publishing and Liz Gurley, title manager for the Images of America: *Milton* project—for their continued devotion to the historical preservation of small towns throughout the United States.

INTRODUCTION

After a US Army militia pursued Sac leader Black Hawk and his band of men, women, and children up the Rock River from southern Illinois in 1832 and into what would become Wisconsin Territory, word spread to the East about the fertile and bountiful land south of the Quaskeenon (Koshkonong) marshland.

In the late 1830s, white settlers from the eastern United States flocked to the area and began staking claims for settlements, which soon took the now-familiar names of Janesville, Edgerton, Whitewater, Milton, Fort Atkinson, and many others.

Each has its own unique story and history worth recapturing and retelling. But perhaps none can match the diverse and benevolent narrative that resulted from Joseph Goodrich's decision in 1838 to stake his claim at the crossing of two militia trails, one running east and west, the other north and south, between what are now Janesville and Fort Atkinson.

It was at that crossing of trails still worn from Gen. Henry Atkinson's pursuit of a community of some 1,100 Native Americans—what later became known as the Black Hawk War—where Goodrich decided to build an inn. That decision not only resulted in the construction of what still stands as Rock County's only National Historic Landmark but also spawned two villages that eventually grew into one city and a small liberal-arts college that fed the minds and hearts of people all over southern Wisconsin for more than 135 years.

Goodrich and his Seventh Day Baptist followers represented an evangelical faction from western New York that in the 1830s headed west with the zeal and conviction of a cavalry charge to spread their moral-high-ground enthusiasm for abolition, temperance, and benevolence. Politically, this movement's intention was to assure that the western territories that were soon to seek statehood would do so as Free Soilers, maintaining a balance in Congress between free states and those allowing legalized slavery.

Goodrich was an innkeeper from Alfred, New York, an area known as the Burned-over District, so named because it had been scorched by the flames of religious revivalism. It was this evangelical spirit and missionary zeal that Goodrich and other Seventh Day migrants brought to the early Du Lac Prairie settlement that became Milton.

There is no definitive tale as to how the community came to be named Milton. One story states that Goodrich intended to charter the community as Prairie du Lac but was rejected by territorial administrators in Madison who feared the name was too similar to the already-chartered Prairie du Sac. Goodrich is said to have then settled on Milton in a nod to English poet John Milton's *Paradise Lost*. Goodrich, it is said, believed his new community was "Paradise Found."

Goodrich's early inn consisted of two wooden structures that would stand until the 1920s. To provide more space for his business and family, which included his wife, Nancy, son, Ezra, and daughter, Jane, Goodrich moved a log cabin that was constructed in 1837 from its location about eight miles east in Lima township to the spot where it still stands behind the inn.

While planning construction of a more permanent inn and home, Goodrich was busily platting a town. He designated land he had secured for a park and square. He gifted other land for a church for the Seventh Day Baptists, whose growing congregation had been meeting for services in the Goodrich home. He also dedicated land for a cemetery and school.

Goodrich decided to construct his inn and apartment-business block with readily available materials indigenous to the area. He settled on the unique idea of constructing buildings from poured grout, made from the sand and limestone prevalent in the area.

Another unique architectural feature of Goodrich's creation was his decision to make the inn portion of the building a hexagon, with a long wing extending off the south side. One section of the business wing survived a 1948 collapse, but the hexagonal inn remains the oldest poured-concrete building in the United States.

While operating his temperance inn, Goodrich worked through the Milton Seventh Day Baptist Church to promote political participation in the cause of abolitionism. Goodrich publicly advocated on the issue but also acted discreetly in supporting radical abolitionists and sheltering fugitive slaves at the Milton House.

A tunnel had been dug linking the pioneer cabin with the basement of the inn, and many accounts relate that the subterranean passage was used by the Goodrich family to hide fugitives as a stop on the Underground Railroad. It was Goodrich's use of his public building to aid the flight of fugitives that led to the building being designated a National Historic Landmark in 1998. The Milton House is indicative of the westward spread of abolition and its transformation from a moral to a political issue.

Goodrich and his activities at the Milton House, where he lived from 1839 until 1867 and sheltered fugitives, illustrate this particular brand of abolitionism that developed in the Midwest in the 1840s. It remains the only documented Wisconsin site of the Underground Railroad that can be toured. The first chapter of this book visually chronicles the history of the Milton House.

Goodrich's local influence did not end with the Milton House. His early activity led directly to the existence of the village of Milton and indirectly, through his visionary railroad influences, the village of Milton Junction. He also founded Milton Academy, which, in the year of Goodrich's death in 1867, was chartered as Milton College by the Wisconsin legislature.

Goodrich utilized the business block of the Milton House as a precursor of a modern-day business incubator. Proprietors operated businesses on the ground floor of the wing and could live over their business in a second-story apartment. Established businesses often moved across the park to what would become a busy village business district.

In 1846, the *Janesville Gazette* described the village, stating that it contained "a well-conducted temperance inn [the Milton House], an excellent Academy, a skillful physician, three dry-goods stores, a post office, a plough factory, a grain cradle factory, two black smith shops, a joiner's shop, two boot and shoemaker's shops, a tailor shop and cooper shop."

The village and area began to rapidly expand in the 1850s due to Goodrich's doggedness to ensure the expansion of rail service west from Milwaukee. In 1850, after constructing the Milton House as a stagecoach inn, Goodrich met with a group of investors seeking to raise funds for continued grading of a rail line west from Milwaukee. Money had run out on the project when the rail was secured to Waukesha. At a meeting of stockholders of the Milwaukee and Mississippi Railroad, Goodrich issued a challenge, pledging to mortgage his landholdings for $3,000 to invest in the line to continue from Waukesha to Whitewater and farther west.

"Are there not 100 men between Milwaukee and the Rock River who can do the same?" Goodrich was quoted as stating at the meeting. "If so, here is my money."

At the time, the investment concept was a unique and innovative idea. After much discussion, the plan was adopted. In the end, Goodrich purchased $10,000 worth of stock. He also gave the railroad grounds for a depot and right-of-way through the public square.

In 1852, the first train was drawn into Milton. Goodrich was viewed regionally as a rail visionary, and a locomotive was named in his honor. After the locomotive was decommissioned, its bell was given to the Goodrich family and is displayed in the front room of the museum.

Goodrich also used his influence to facilitate the arrival of a north-south rail line to intersect with the east-west line a mile west of his Milton House. Soon, the separate thriving burg of Milton Junction began growing around that rail intersection. The result of Goodrich's vision was that, over the next 100 years, Milton and Milton Junction became the main rail hub for trains traveling north and south between Madison and Janesville toward Rockford and Chicago to be diverted east toward Milwaukee.

The idea that the junction of these rail lines was a mile down the tracks from the center of the village of Milton sat well with Goodrich. He was well aware that the influx of passenger trains would result in a demand for hotels along with pressure on the community to succumb to the notion of serving alcohol.

By the mid-1860s, the first Morgan House hotel was built in Milton Junction, and the large St. Paul Hotel soon followed. As many as 30 to 50 trains per day were pulling through Milton Junction in the late 1800s. As Goodrich predicted, alcohol followed and created perhaps the biggest and most obvious contrast between the village of Milton and Milton Junction as both downtowns grew and prospered during the first half of the 1900s. Taverns were prevalent along Milton Junction's Merchant Row but not on Milton's Main Street.

That did not mean the people of Milton did not imbibe with their Junction brethren. A long-standing joke about the unique situation goes, "The front doors of the Merchant Row taverns were for Junction folk. The back doors were for the people from Milton." That was true right up until as late as 1970, when the first liquor license was granted on Milton's east side, three years after the villages merged into one city.

Milton was incorporated as a village in 1904, but Milton Junction operated as an unincorporated village through the late 1940s. As such, Milton Junction was a part of the mostly rural Milton Township and governed by the Milton Town Board. In 1949, Milton Junction was incorporated as a village, but the township and new village continued to share certain assets, including the fire department.

Through the 1960s, the village boards began serious negotiations about the advantages of merging into one city. Following a heated referendum in 1967, the villages merged, with Junction village board president Lawrence Dickoff serving as the new city's first mayor.

The final chapter of Joseph Goodrich's legacy began when he founded Milton Academy. The grout academy building was built in 1844 near the northwest corner of the public square when there were only four dwellings in the village. Construction cost about $300, paid by Joseph Goodrich, who managed the school and bore its expense in its first years. Tuition was $3 per 11-week term, of which there were three a year; board with private families was $1 to $1.50 per week, and there were 67 students, 40 gentlemen and 27 ladies.

In the 1850s, the college moved to the top of the hill overlooking the village with the construction of two brick buildings that became Main Hall and Goodrich Hall. From there the school grew to an enrollment peak of about 860 in 1970. Declining enrollment, a heavy debt burden, and lack of substantial endowments each factored into the demise of Milton College and its closure in 1982.

For the better part of 135 years, the Greater Milton community was two villages with a college, and no one could have imagined things any other way. Now, in 2016, many of Milton's 5,500 residents cannot imagine Milton ever having a college.

Yet still standing as a rock is the Milton House, the community's beloved National Historic Landmark, which is a reminder of the vision and benevolence of Joseph Goodrich and the many ways he helped shape Milton into the community it is today.

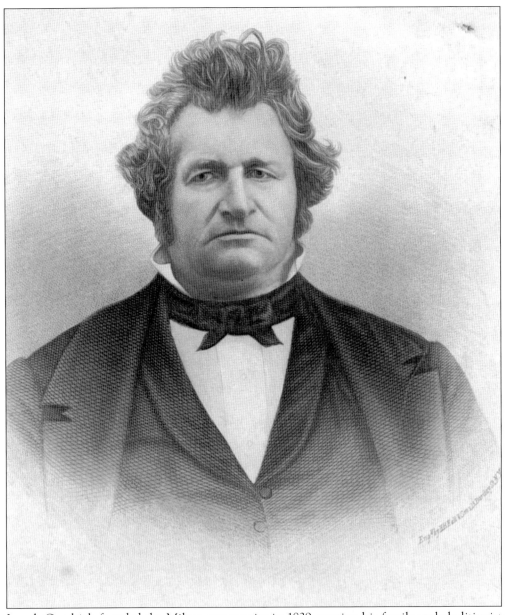

Joseph Goodrich founded the Milton community in 1839, moving his family and abolitionist views from Alfred, New York. Goodrich platted a new community by securing land from the territorial offices in Madison and then donating acreage for a park, church, cemetery, and schools. He constructed a hexagonal temperance inn made of grout that he soon used as part of the Underground Railroad to help fleeing fugitive slaves

One

MILTON HOUSE

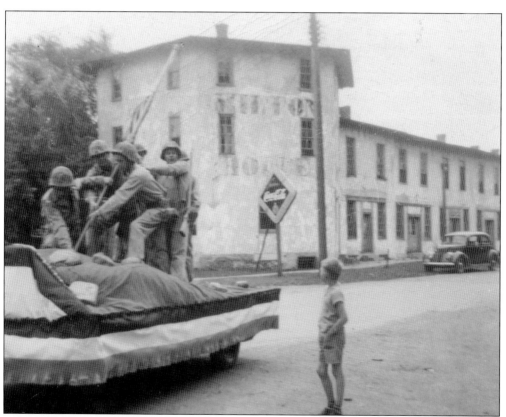

The Milton House is without question the most iconic building in Milton, if not all of Rock County. It continues to be one of the most photographed structures in southern Wisconsin. This photograph combines the Milton House with another iconic image of its day—that of a living depiction of the Iwo Jima flag-raising on a Fourth of July float in 1947.

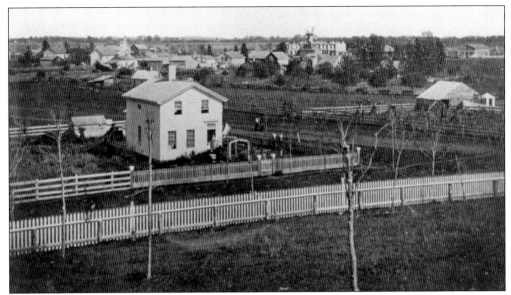

This is the oldest known image of the Milton House, taken across the young village from the hillside of Milton College's main hall. The photograph was taken prior to 1867, when the third floor of the inn's hexagonal tower was added. Also visible in front of the Milton House is the original windmill of the train depot.

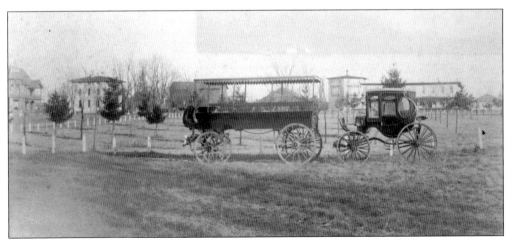

This photograph from the 1870s shows a pair of carriages that were most likely built in a shop owned by Ezra Goodrich and were displayed on the west end of North Goodrich Park. The background shows the Milton House complex. On the left is Ezra Goodrich's brick home.

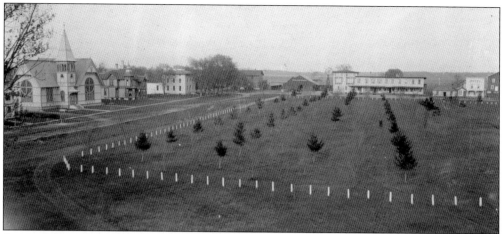

Some of the early images of the Milton House were portrait photographs taken from the Ellery Burdick gallery, located across Goodrich Park from the Milton House. This photograph is from the spring of 1881 and shows the young trees of the park. It also illustrates the layout of the square from the Richmond Hotel on the right and the Milton House, stable, creamery, Goodrich House, and lastly, the Seventh Day Baptist Church.

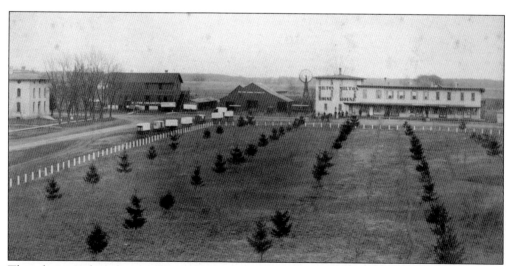

This photograph is dated 1885 and shows how busy the creamery was on certain days, with a line of horse-drawn wagons awaiting their loads. This is how the Milton House looked when president-elect Grover Cleveland signed the inn's guest register in January 1885, two months prior to assuming office. A large copy of this photograph hangs in the museum's model room.

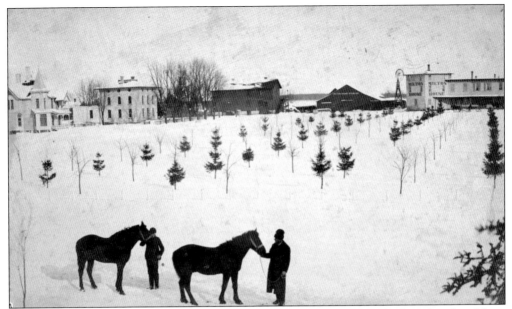

This photograph of a man and a boy holding horses in the snow of Goodrich Park is dated from 1879. It was likely taken from the elevated angle afforded by Ellery Burdick's photography gallery. The "Goodrich Hall" lettering on the creamery building is evident in this image.

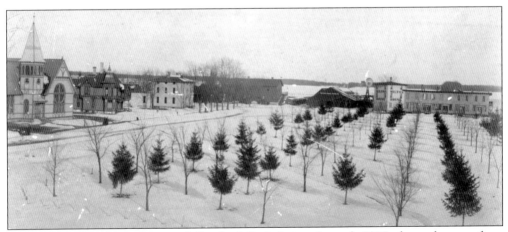

This photograph of a snow-covered Goodrich Park during the early 1890s shows the trees from earlier images maturing nicely. The Seventh Day Baptist Church is the dominant building on the left. The church burned and was rebuilt in the early 1930s. The house between the church and brick Goodrich house was razed in the early 2000s.

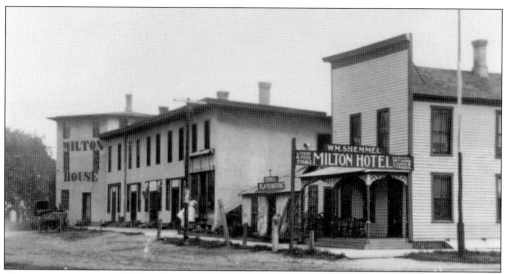

The hotel next to the Milton House did a brisk business during the late 1800s once rail traffic increased through the village. W.M. Shemmel was the hotel's proprietor when this photograph was taken in the first decade of the 1900s. The sign advertised a stable, lunches, soft drinks, cigars, and tobacco.

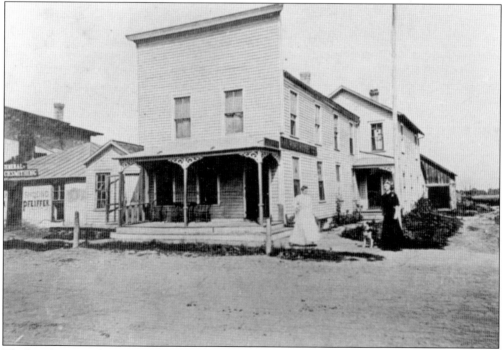

The hotel next to the Milton House was known as the Richmond House prior to W.M. Shemmel's proprietorship. The sign reads "Railroad House," and the livery stable can be seen in the background. In later years, Earl Young ran a general store with curbside gas pumps out of this building. The building fell into disrepair and was razed in the 1960s.

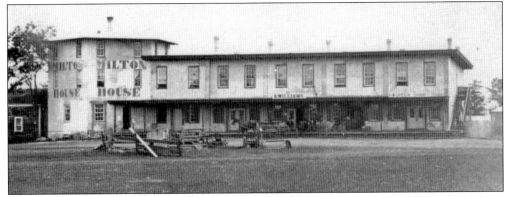

Businesses in the Goodrich Block kept a steady flow of local traffic coming to the Milton House in the late 1880s and early 1890s, when this photograph was taken from the park. R. Williams advertised dry goods and groceries in the Milton House Inn's guest registry.

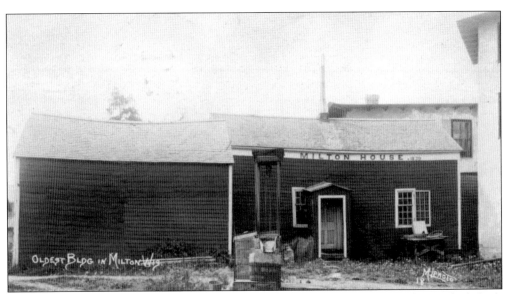

These two wooden structures were among the first buildings in Milton. Joseph Goodrich built them in 1839 adjacent to a log cabin he had moved to the site from Lima Township. The buildings housed the Goodrich family and were used as an inn for travelers while the construction of the Milton House was being completed. The buildings were torn down in the late 1920s.

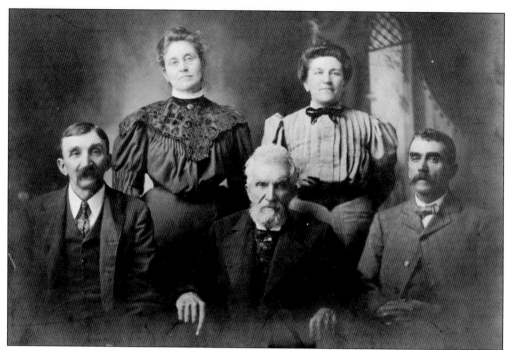

Ezra Goodrich took sole proprietorship of the Milton House in 1867 upon the passing of his father, Joseph. A colorful local character who feuded regularly with college and railroad administrators, despite facilitating the growth of each, Goodrich ran the inn until the early 1890s and died in 1916 at age 90. In this portrait, Goodrich is surrounded by his children, sons William Henry (left) and Joseph Charles and daughters Mary Elizabeth (left) and Anna Selina.

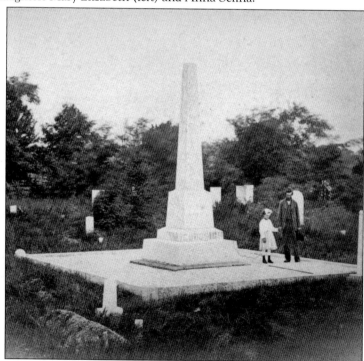

Ezra Goodrich and one of his two daughters survey the Goodrich family plot in the Milton Cemetery and the monument marking the final resting place of Joseph Goodrich. Joseph Goodrich set aside land for the cemetery, located about a quarter of a mile north of the Milton House, when he platted the town in the late 1830s.

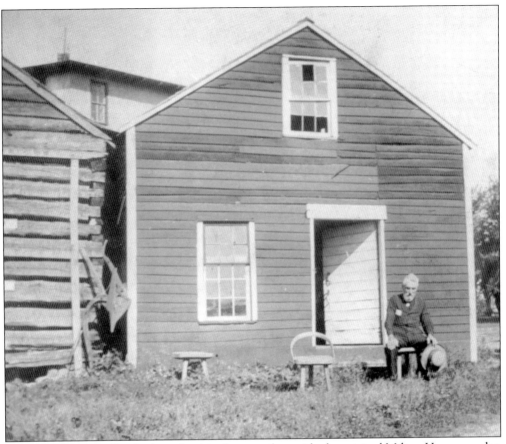

Late in his life, Ezra Goodrich sat for this photograph outside the original Milton House wooden structure built by his father in 1839. This view faces west, with the pre-restoration cabin on the left. The handmade stools and chair remain on display in the museum's cabin.

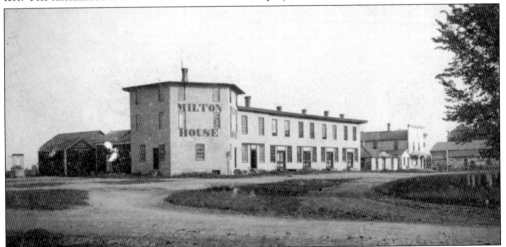

This is the way the Milton House looked late in the life of Ezra Goodrich, who passed away in 1916. The building looked well maintained and the original wooden Milton House buildings constructed in 1839 still stood and can be seen, along with the original well, on the left.

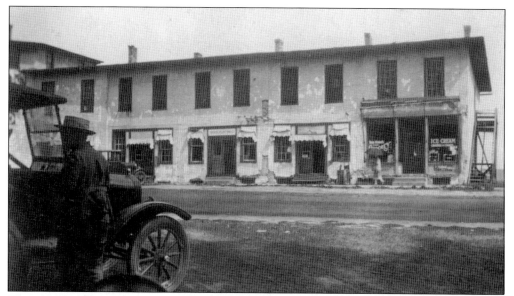

This photograph taken from the park on a rainy day (note the woman on the sidewalk with an umbrella) shows several businesses in operation in the Goodrich Block in the early 1920s. The shops included a grocery store on the south end of the wing and Davis Printing in the middle portion of the block.

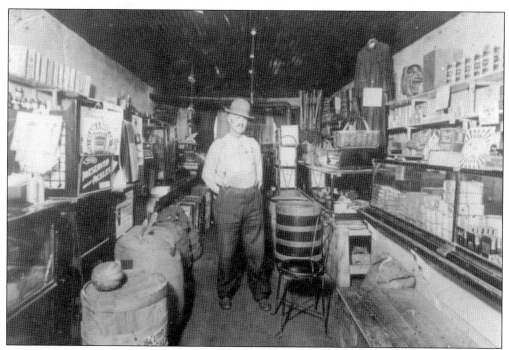

James Fetherston operated a grocery and general store in one of the Goodrich Block sections in the early 1920s. Fetherston was born in Ireland and farmed in Johnstown and Harmony Townships before moving to Milton and becoming a storekeeper. This photograph illustrates the narrow, linear nature of the Goodrich Block business spaces.

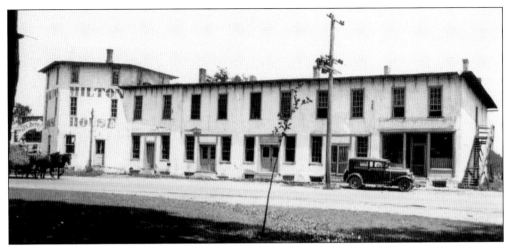

This is one of the more famous images of the Milton House, taken during the early 1940s on a day when a farmer was hauling hay on a wagon pulled by horses past the building. Visible on the left is a sign for the service station that operated in the stable building. A large version of this image hangs on the wall of the museum's model room.

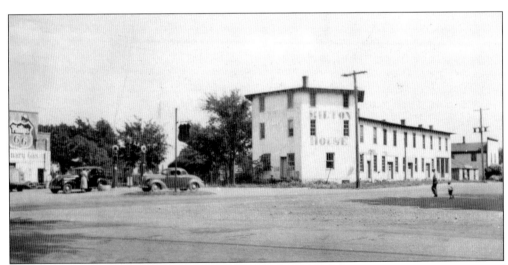

In the 1930s and early 1940s, a Phillips 66 service station with gas pumps was operating out of the old stable building, which still stands on the north end of the Milton House grounds. About this time in the history of the inn, several of the rooms in the hexagonal tower were being used by Milton College to house students.

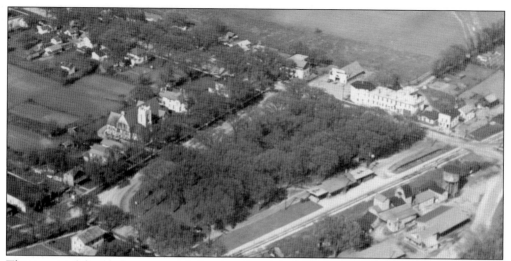

This is one of the few known aerial photographs of the Milton House prior to the wing collapse in 1948. Taken during the early to mid-1940s, the photograph shows the stable building to the north of the Milton House when it was used as a service station. Goodrich Park was covered with mature trees, and the train depot and lumber yard can be seen to the south of the park along the rail tracks.

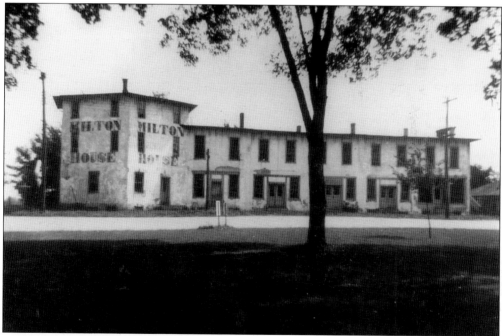

This photograph of the Milton House taken from North Goodrich Park in the late 1940s shows what the building looked like just prior to the wing collapse of 1948. Evident in the image is the structural decay from years of neglect. An informal "keep out" sign is painted on the door of the first wing section.

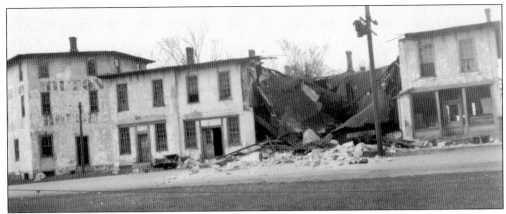

The Milton House forever changed on the evening of Friday, April 30, 1948, when two sections of the Goodrich Block collapsed. A variety of factors led to the collapse, including the fact that business tenants of the wing often removed support beams and walls from the lower floor or basement without realizing the structural integrity of the building was being compromised.

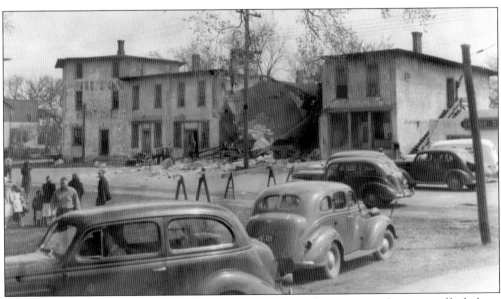

The morning following the collapse, many community members came to the site to offer help or to simply have a look at the damage. The street in front of the building was blocked and traffic diverted as local contractors were mustered to survey the damage, deal with the rubble, and save as much of the remaining building as possible.

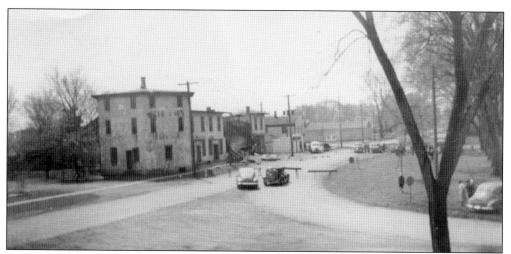

Seven tenants living in the second-story apartments of the wing were displaced by the collapse. Albert Serns was asleep in one of the apartments when his bed fell to the first floor. The 57-year-old sustained just minor injuries despite being pinned under a large piece of concrete for several hours. No other injuries were reported. This photograph was likely snapped from one of the upper floors of the Goodrich House.

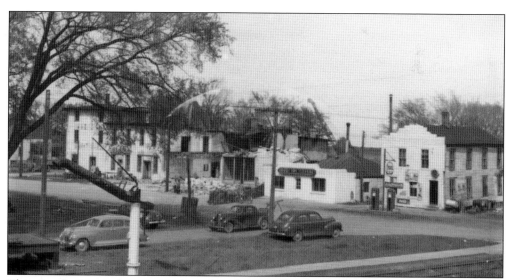

This view facing northeast was taken after cleanup efforts were underway and shows the top of a crane set up on the back side of the building. The prominent building to the right is Earl Young's general store, which stood until the 1960s at the original site of the Richmond Hotel. Also visible in the left foreground is the water spout from the train depot.

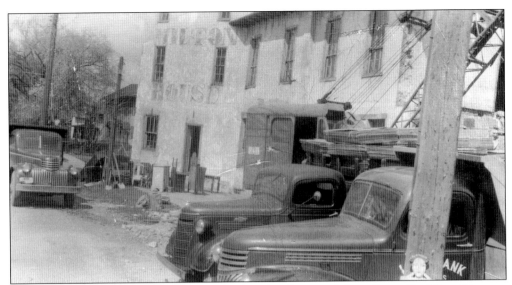

Local contractor Leo Frank was instrumental in the cleanup of the collapsed building. Here are Frank's trucks lined up on the front side of the building along with the crane. Furniture removed from the inside of the building can be seen on the sidewalk in front of the tower.

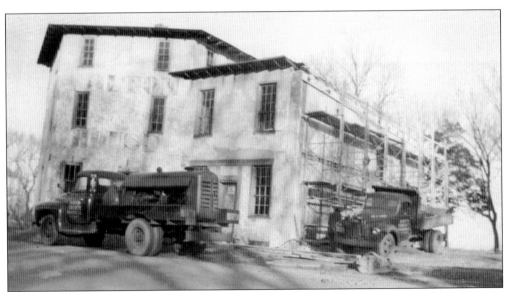

Cleanup of the collapsed Goodrich Block revealed that only one of five sections of the wing was structurally sound enough to be saved. The hexagonal tower and one section of the wing was all that stood following the collapse. Shown here are trucks from Hirth Construction as the south wall is being finished.

This is how the Milton House appeared following the cleanup and renovation efforts in the early 1950s. The conversion of the building to a working museum by the Milton Historical Society was completed over a little more than a five-year period from the time of the Goodrich Block collapse until the museum opened to the public in 1954.

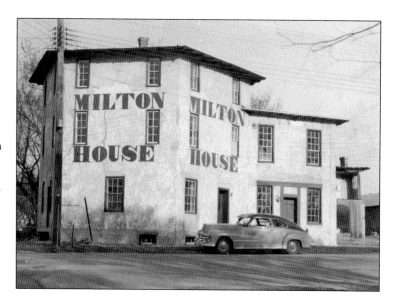

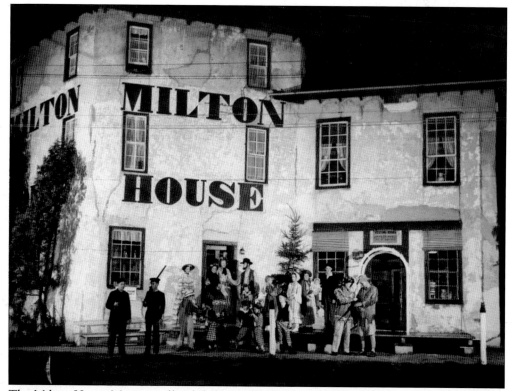

The Milton House Museum official dedication on July 31, 1955, included a dedicatory pageant that was presented on four consecutive evenings. Bleachers providing seating for about 5,000 spectators were erected in the park across from the museum. *Milton Memories*, written by Winnie Crandall Saunders and performed by a cast of hundreds of community members, dramatized the activities of Joseph Goodrich as he platted the town and built the Milton House.

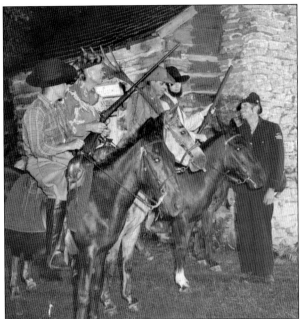

This scene from the 1955 museum dedicatory pageant features a young Abraham Lincoln, played by Les Rusch, addressing members of Dodge's Rangers, portrayed by Lee Scoville, Fran Dimmig, Roger Schwartz, and William Bliss. Lincoln was a foot soldier in the militia that pursued Sac Chief Blackhawk's people through the area six years before Goodrich arrived.

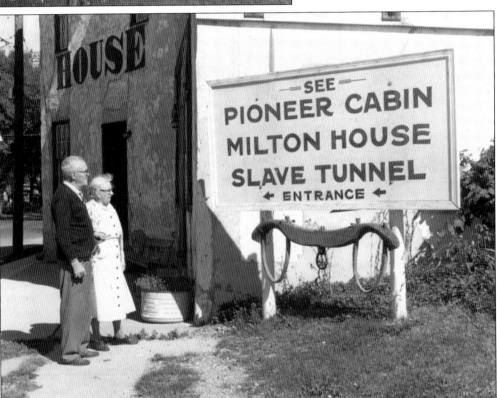

During the early years of its operation, the Milton House was a seasonal museum offering tours from May through September each year. It was not until the completion of the 2006 expansion that the museum could be open year-round. Pictured here at the opening of the 1960 tour season are museum curators Rev John and Emily Randolph.

Shown here during the early days of the museum are three women who each played important roles in preserving Milton's history. From left to right are Julia Lois Goodrich, great-granddaughter of Joseph Goodrich; La Donia Marquart, president of the Milton Historical Society at the time the Milton House was transitioned to a museum; and Dr. Rachel Salisbury, a Milton College English professor who founded the Rock County Historical Society.

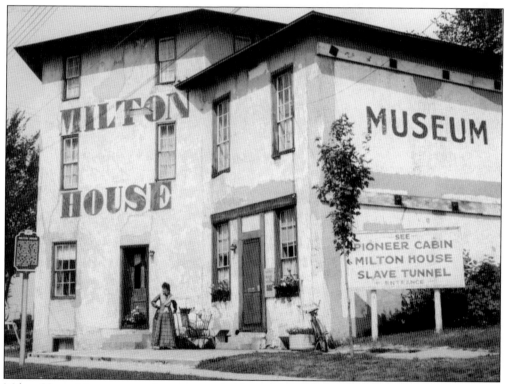

Milton House Museum tours became popular during the 1960s, with 8,000 to 10,000 visitors each year when the museum was open from May through September. It was common for tour guides, such as longtime museum guide Margaret Coon, to wear period garb. Today's museum guides and docents dress in period attire on special occasions.

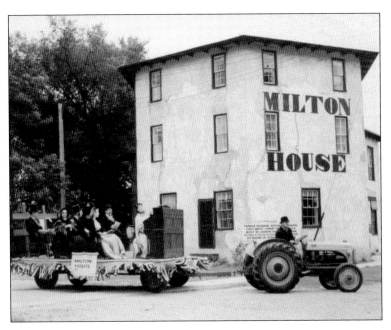

The Milton House and Historical Society often had a float and presence in the community's Fourth of July parade, which traveled past the museum in the 1950s. This float consisted of a hay wagon pulled by a small tractor and featured Betty Daland on the piano accompanying a small group of singers.

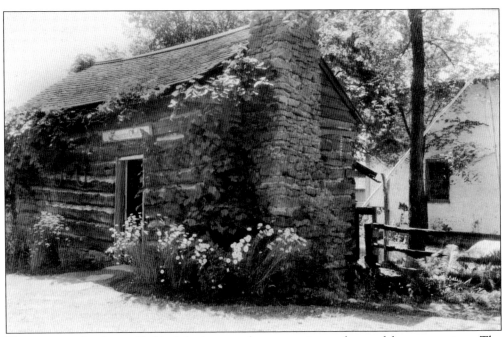

The pioneer cabin located behind the inn soon became an integral part of the museum tour. The cabin, built in 1837, was moved by Joseph Goodrich from Lima Township to its present location in order to give his family more room during construction of the Milton House. The cabin was connected to the inn by a tunnel that Goodrich—a staunch abolitionist—used to hide and move fugitive slaves.

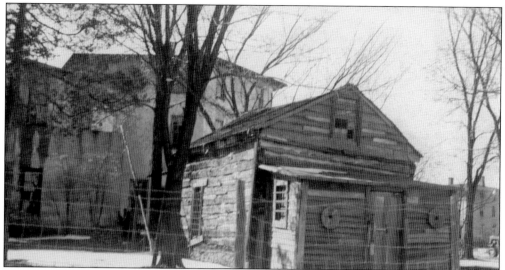

The cabin, with its large stone fireplace, served as the food-preparation area for the inn. During its latter years as a working cabin, a lean-to annex was constructed on its east end. The small annex gave the cabin more room and was still standing in the 1930s.

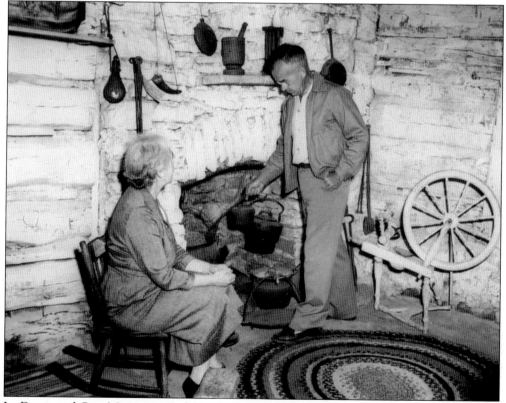

La Donia and Carr Marquart are shown here in the newly renovated cabin about the time the museum opened for tours in 1954. La Donia Marquart served as president of Milton Historical Society at the time it purchased the Milton House property from the Goodrich family and was instrumental in guiding plans to turn the property into a working museum.

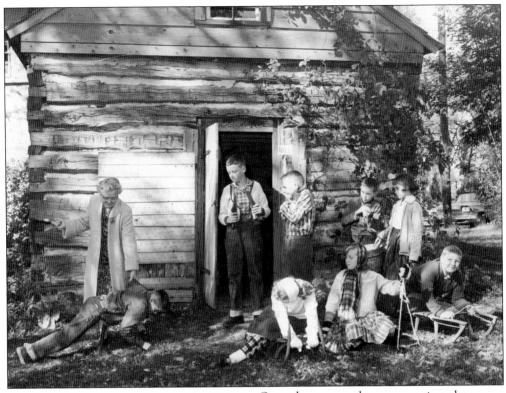

Once the museum began operating, the Milton Historical Society reached out to local schools to involve students in educational and sometimes comical history lessons. In this photograph from 1960, Marjorie Burdick demonstrates what often happened in pioneer days during recess. Students learning the tough lesson include Kerry Hull, Gayle Wakefield, Steven Drays, Karen Hill, Vivian Oswald, Debbie Randolph, and Jim Goodger.

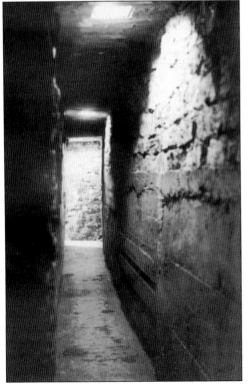

From the time the museum opened in 1954, one of its main attractions and fascinations has been the 45-foot tunnel connecting the pioneer cabin with the basement of the inn. Ezra Goodrich claimed that his father, Joseph, used the tunnel to hide fugitive slaves beginning in the 1850s. The original tunnel was four feet deep and unlit, and allowed fugitives access from the cabin to the inn's basement, where they were fed and sheltered.

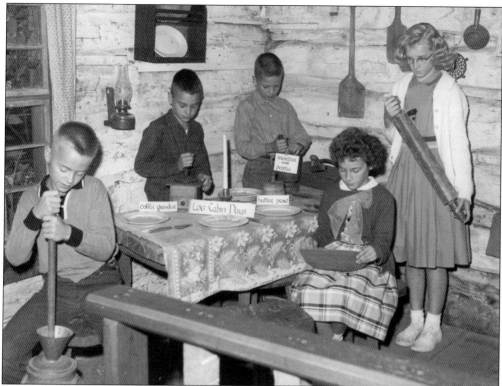

The museum soon became a great venue for local students to become involved in living history projects. Pictured here in 1961 is a group of Milton fifth graders participating in Log Cabin Days. Those students working inside the museum's cabin include Skip Drew (churning butter), Randy Marsden (grinding coffee), Jim Woodman (at the mortar and pestle), Sharon Hinkle (with the bowl) and Alice Rood (sporting the large rolling pin).

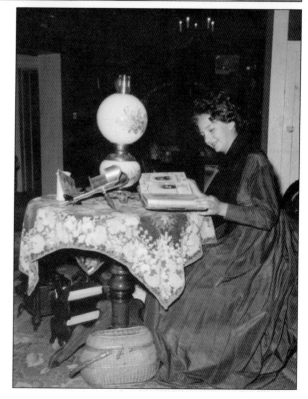

The museum also made a nice setting for period-style photographs that could be used for promotions. In this 1964 photograph, Ann Williams is dressed in period garb as she pages through an old photo album while seated in the museum's sitting room. A lamp and old-fashioned stereoscope made fine tabletop props.

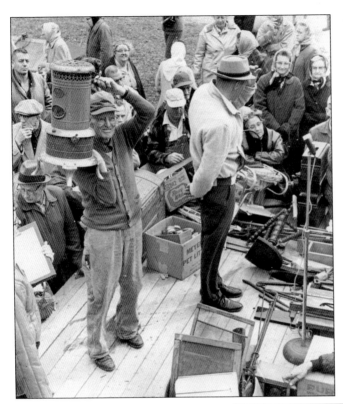

The Milton Historical Society often held community auctions as a way of raising funds to pay for the operating expenses of the Milton House Museum. This 1964 auction was held on the museum grounds; Alf Addie is holding up a kerosene stove while auctioneer Darrell Weber works the crowd for bids.

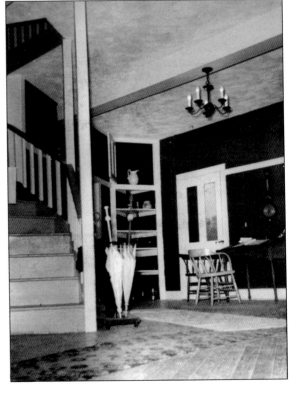

Rooms and displays in the museum evolve and change over time. This is how the inn lobby appeared in the 1960s. At the center of the photograph is the corner shelving on the southeast portion of the room. To the left is the spiral staircase, which wraps around the chimney leading to the upstairs rooms that were once used by coach and rail travelers.

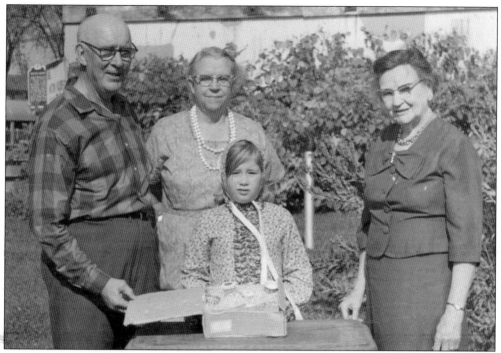

In 1968, twenty years after the collapse of the Goodrich Block and near the end of the museum's 15th season, Luann Curtiss, a third grader at Janesville's Adams School, was recognized as the 100,000th visitor to the Milton House Museum. She was presented a set of doll dishes by Milton Historical Society members (from left to right) Gerald Sayre, Rachel Salisbury, and Mabel Nelson.

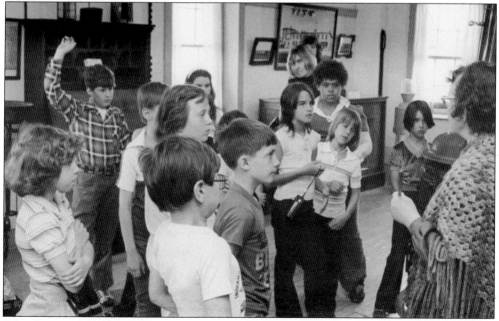

School tours of the Milton House Museum have long been the staple of spring field trips for many schools in the Southern Wisconsin area. Here longtime museum tour guide Geraldine Anderson (right) addresses a group of students in the lobby of the inn during a 1981 school tour.

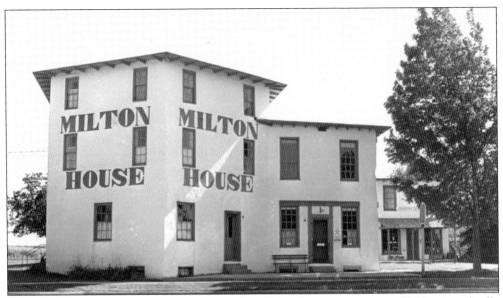

This photograph of the Milton House from the 1990s is how a generation of Miltonians fondly remember the museum. It is how the museum looked from the aftermath of the wing collapse in 1948 until the new addition was constructed in 2006. For 60 years, the museum was open seasonally from May through October of each year.

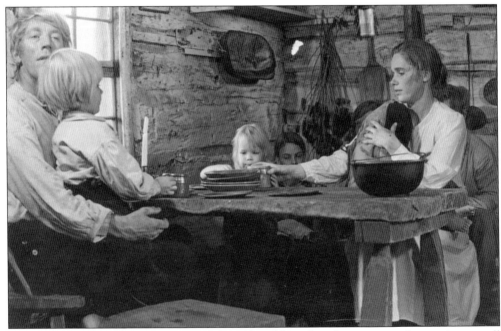

The unique history and architecture of the Milton House has drawn national attention as well as a Swedish film crew in 1971 for on-location filming of the feature film *The Emigrants*. The movie's stars, Max von Sydow and Liv Ullmann, are pictured here during a scene shot in the museum's pioneer cabin.

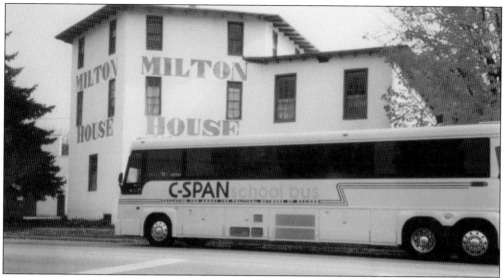

The notoriety of the Milton House Museum continued in the mid-1990s when the C-SPAN School Bus came by for a visit. The bus includes a mobile television studio, which allowed the cable news network to produce news and documentary features at local locations. C-SPAN's focus on the role of Joseph Goodrich and the Milton House in the abolitionist movement played to a wide national audience.

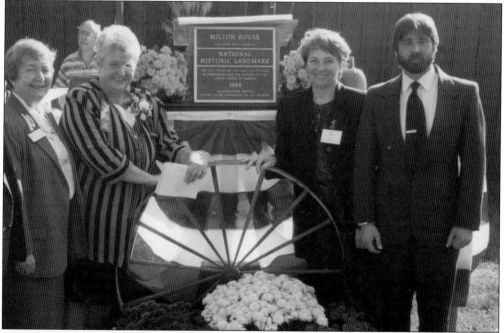

The designation of the Milton House as Rock County's only National Historic Landmark recognized the building's historical significance as a documented site on the Underground Railroad and as an illustration of the westward spread of abolitionism. This photograph from the 1998 landmark dedication ceremony includes, from left to right, state senator Joanne Huelsman, Milton House executive director Judy Scheehle, Pat Albaugh of the Michigan Underground Railroad Association, and Milton mayor Brent Sutherland.

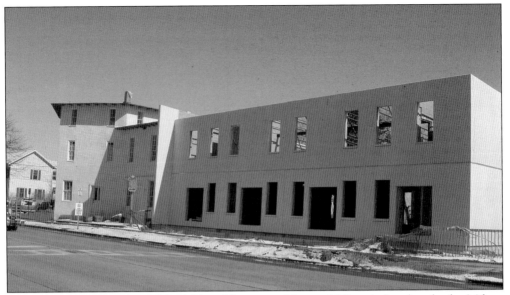

Following the designation of the Milton House as a National Historic Landmark, the Milton Historical Society began fundraising efforts to complete an addition that would allow the museum to be open year-round and once again serve as a community gathering place. The addition, completed in 2006, replicates the original Goodrich Block wing that stood prior to its 1948 collapse.

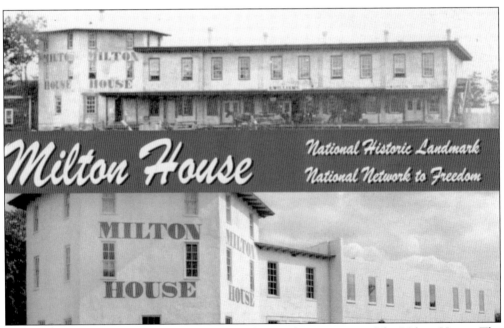

This 2014 postcard shows a pair of contrasting then-and-now images of the Milton House. The top image is of the Milton House when it was still being used as an inn and business hub in the early 1890s. The bottom shows how the museum currently looks as a working museum following its designation as a National Historic Landmark and the 2006 construction that replicates the collapsed wing of the original structure.

Two

VILLAGE OF MILTON

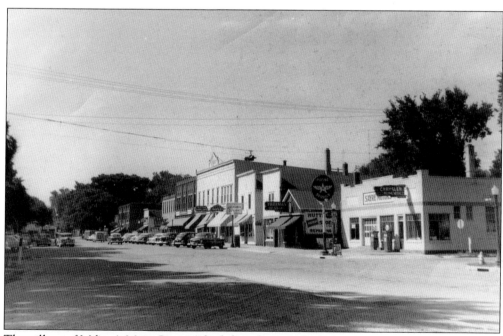

The village of Milton's Main Street, which later became Parkview Drive, was a bustling area in the 1950s. This is the north end of Main Street, where Sayre Motors sold Chryslers and owned and serviced school buses. Hutter Shoes, which became Howard Daley's, is the first of a string of shops, businesses, and restaurants that did a brisk business across from the park.

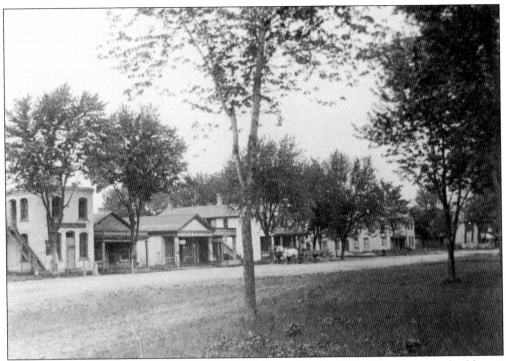

The south end of Main Street was a dirt and gravel road in the 1890s. The two-story building is the Bank of Milton, built in 1884. The frame structure just to the north of the bank was Walter Rogers's ice cream parlor. W.W. Clarke ran the book and stationery store, and his brother W.P. Clarke operated a drugstore in the same building.

This is the same group of buildings about 10 years after the previous photograph. The post office operated beside the Clarke building. The wooden structures were replaced in 1916 by the brick Whittet building. During construction of the new building, the post office moved to the Goodrich Block of the Milton House before moving back to Main Street.

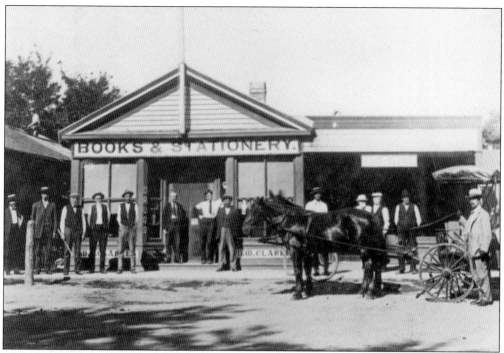

This is the outside of the Clarke building during the first decade of the 1900s. Gathered for the photograph are, from left to right, Milton College president William C. Daland, Byron Wells, Paul Green, Ben Stillman, John Davidson, W.P. Clarke, Ray Clarke, Bert Risdon, Stiles Lanphere, Ray Rood, Ben Curtiss, Wellington Clarke, and with the horses, Fred Bliss.

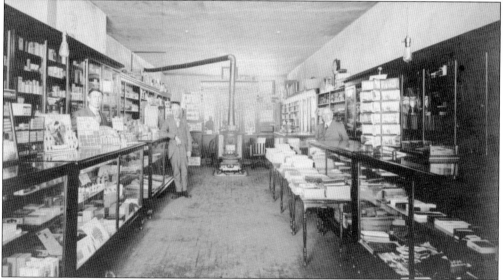

The interior of the Clarke bookstore in the early 1890s featured attractive display cases on each side of the long, narrow store. William Wallace Clarke (center) came to Milton from New York in 1856. He worked for Robert Williams, a merchant in the Goodrich Block of the Milton House, until 1881, when he opened his own book and stationery store on Main Street. He died in 1922 at age 85.

This view of Main Street from the early 1900s shows the J.P Bullis building as the dominant structure. The Dunn and Boss building at the corner of Main and College Streets is obscured by trees. Down the street is the T.I. Place building and then the wooden structures housing Clarke's and the ice-cream parlor, with the bank at the end.

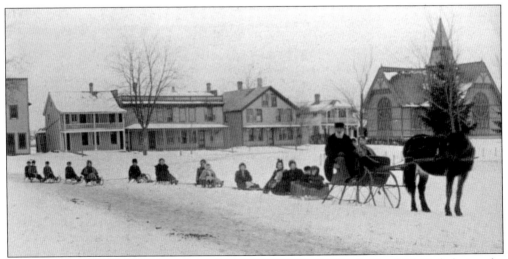

A string of sleds was attached to a cutter for some winter fun in North Goodrich Park during the 1890s. In the background are buildings that once lined the north side of Madison Avenue. From left to right are the livery stable, the home of Mr. Campbell, the village constable, the GAR Hall, the Harrad Jackson home, and the Seventh Day Baptist Church, built in 1883.

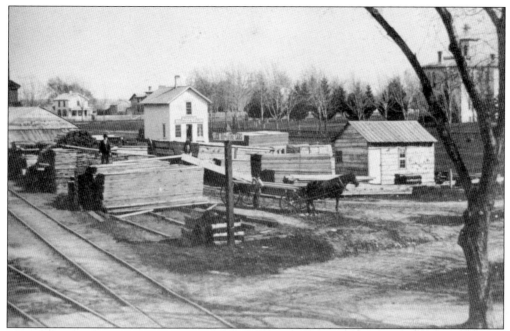

The village's lumber yard is pictured here from Ellery Burdick's gallery prior to 1904. Located just west of the original train depot on the south side of the train tracks, the lumber yard operated under a variety of owners into the 1960s. The first Milton grade and high school, built in 1869, can be seen in the background.

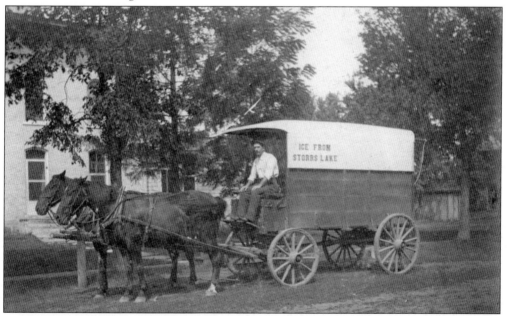

Joseph Charles Goodrich, son of Ezra and grandson of Milton's founding father, Joseph Goodrich, carried on his family's commitment to the community, serving on the village board and school board for many years. For a while he operated the Storr's Lake Ice Company, posing for this photograph while on an ice wagon outside of the Goodrich House. He died at age 63 in 1917, one year after his father passed.

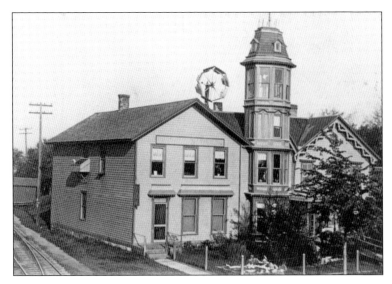

The Ellery Burdick Photograph Gallery was a distinctive landmark at the intersection of the rail tracks and Main Street, now known as Parkview Drive. The building stood until the 1940s. In 1956, the brick building that housed the village post office was constructed on this site and still stands as a real estate office.

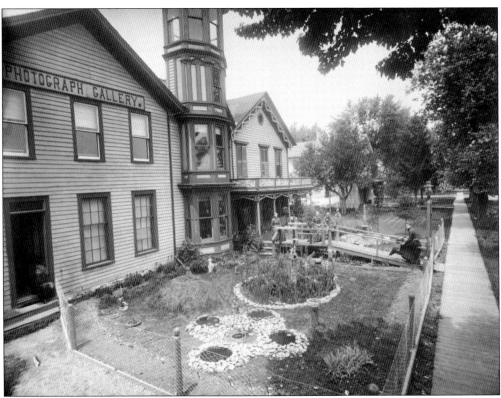

Many of the Milton-area portraits taken in the late 1800s and until about 1915 originated at the Burdick Gallery, which took advantage of the building's unique landscaping for outside photography. Located across the park from the Milton House, the gallery was also the source of many of the unique portraits of that Milton landmark.

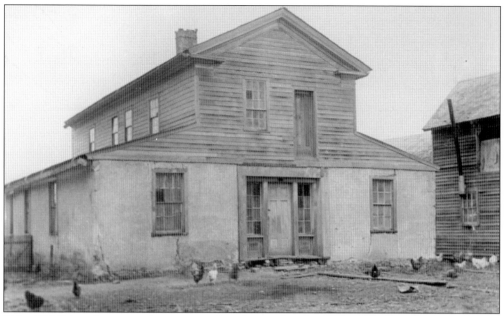

"The Old Palace," as it was known, stood at the north side of Madison Avenue at Main Street until about 1902. Built in 1843 by Abraham Allen and soon sold to Joseph Goodrich, the first story was grout and the second made of wood. Goodrich's original Milton Academy building also stood in this vicinity, and the Palace was said to have been used for classes once the grout academy building was no longer tenable.

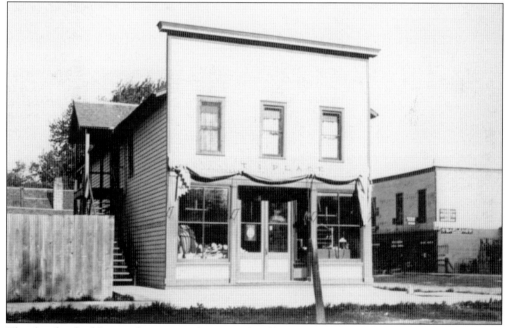

This familiar building at the corner of Main and College Streets was moved to that location in the 1870s. It was sold to Thomas Irwin Place, who carried on his business there well into the 1900s, selling china, musical instruments, and jewelry and performing clock and watch repair. In later years, the building housed Kumlien Laundry, Emanuelle's Pizza, and Georgio's Pizza.

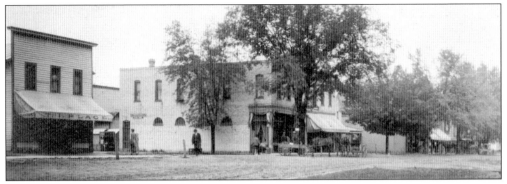

T.I. Place operated his jewelry store on Main Street for 55 years. Upon his death in 1940 at age 78, he was the dean of all business owners in the village. He served on the village board and was village president for many years. This is how his store and Main Street looked in the 1890s.

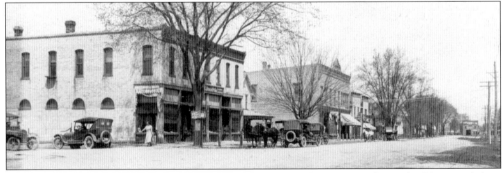

Across College Street from the T.I. Place jewelry store was the Dunn and Boss building, and then the J.P. Bullis building. Between the two large buildings was the Cottage Hotel, which operated for a few years before closing in 1920. A combination of horse and buggies and automobiles line Main Street, with the livery visible at the end of the street.

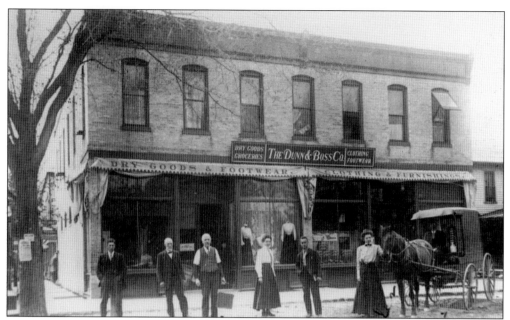

Arthur Dunn and George Boss were business partners and erected this building in 1891, which still stands at the corner of Parkview Drive and College Street. Dunn ran a clothing store in one half of the building and Boss a grocery store in the other. In later years, the building housed businesses such as O'Connor's Pharmacy, Western Auto Hardware, the Corner Closet resale store, and Robin's Nest Salon.

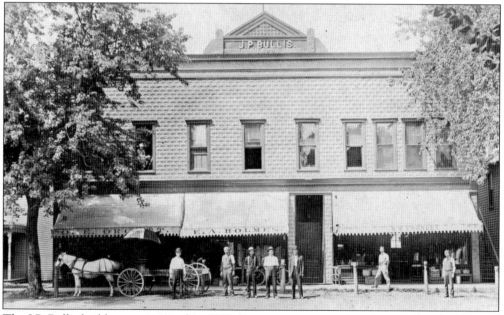

The J.P. Bullis building was erected in 1899. Business owners in this photograph taken around 1910 include O.E. Orcutt, E.A. Holmes, Ed Green, Pitt Holmes, Lew Babcock, and Nathan W. Crosley. Orcutt was a barber by trade, and his store on the left remained Cal's Barbershop as late as 2015. E.A. Holmes operated a general and grocery store for many years. Crosley operated a meat market.

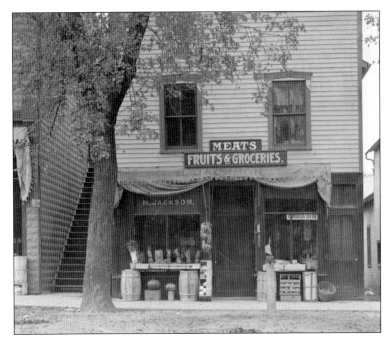

Harrad Jackson built this building in the 1880s before the Bullis Block was erected just to the south. Jackson opened a meat market there and also sold meat from a wagon filled with ice. He retired about 1920, and the building was sold to the Milton Power Company. Wisconsin Power and Light bought Milton Power and maintained an office in the building until the 1960s.

The Harrad Jackson home was two houses west of the Seventh Day Baptist Church, facing Goodrich Park. In 1879, Jackson emigrated to the United States from England, settling in Milton. This photograph was taken in about 1890, and Jackson is in the dark suit to the left of the two women. To Jackson's right is his son-in-law, S.S. Summers, who became Milton's postmaster. Harrad Jackson died in 1933 at age 91.

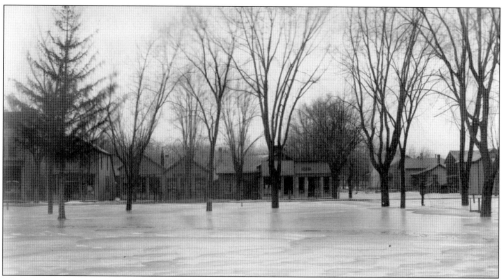

This photograph taken from the school yard during the spring flood of 1911 shows the wooden buildings at the corner of Main and Greenman Streets. The corner building, which later became the site of Sayre Motors, was a barbershop owned by Emil Wieglef, a Civil War veteran and active member of the Milton GAR. To the south was a boot and shoe store, bakery, millinery, and Jackson's Meat Market.

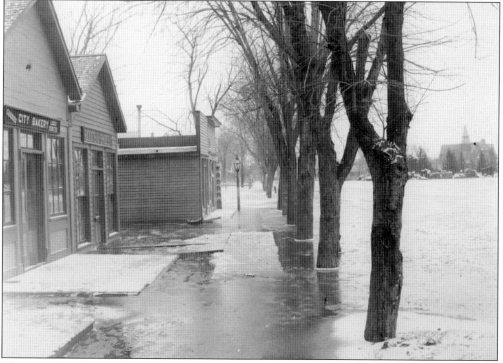

This street-level view of the 1911 flood shows the facing of the bakery, boot and shoe store, and the barbershop. Most of these buildings were razed by 1926, when the corner service station was built by Eb Starks and later sold to Walt Sayre. The Seventh Day Baptist Church can be seen in the background on the right.

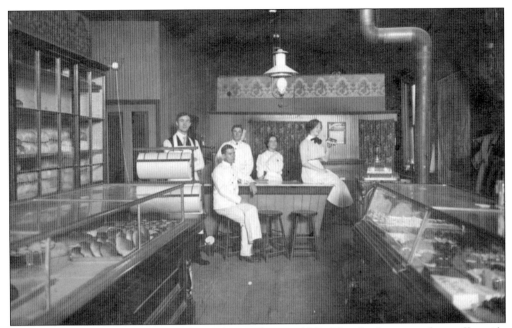

This is a scene from the inside of the Milton Bakery in 1912. The display cases show off a wide range of cakes, breads, and other baked goods. The staff includes, from left to right, Guy Eaglesfield, Lou Hurley, Harry Talcott, Edith Hoag Hurley, and Bess Crandall.

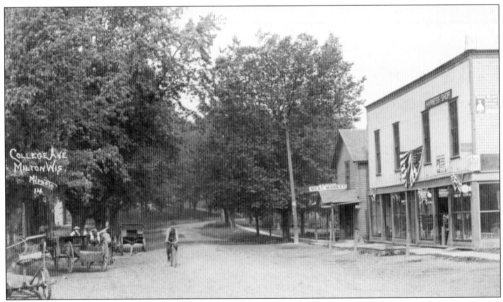

This is a view looking west up College Street from Main Street in 1909. An implement dealer operated for many years on the south side of the street. On the north side was the A.M. Van Horn Meat Market, and a larger building housing Maxson Hardware and a harness shop.

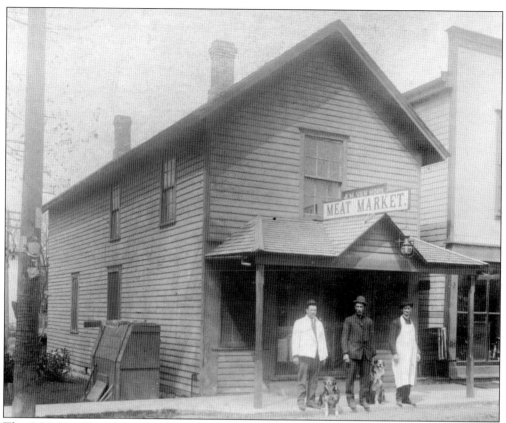

The A.M. Van Horn Meat Market was a forerunner of several markets or small grocery stores to operate on College Street throughout the 1900s. This building burned in 1914, but grocery stores on the block were later operated by Harry Crandall, Loyal Hull, Ken Ochs, and Bill Buchholtz, who renamed it College Street Grocery.

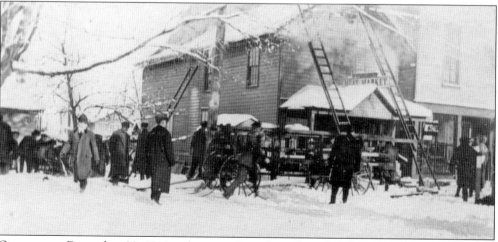

On a snowy December 30, 1914, volunteers from the village fire department rushed to try to rescue the A.M. Van Horn Meat Market from a fire. Ladders were set up to the building's roof, and a horse-drawn pumper apparatus was stationed in front of the burning structure. Despite their efforts, the building could not be saved.

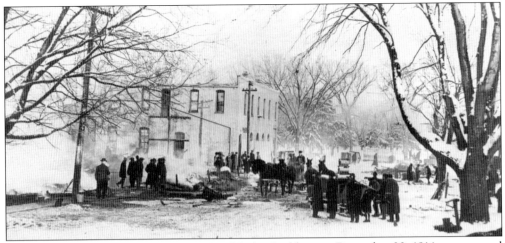

The fire that began in the Van Horn Meat Market building on December 30, 1914, soon spread to the neighboring Maxson Hardware Store. By the time the fire was finished, both buildings were lost, and the only structure in sight from this photograph was the back end of the Dunn and Boss building on Main Street.

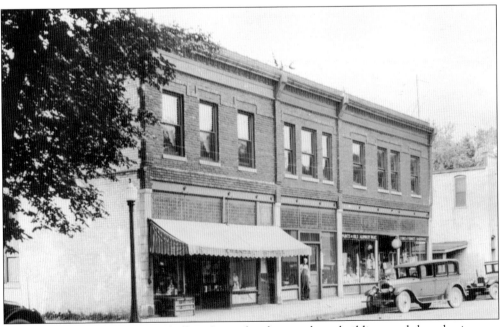

Two years after the devastating College Street fire destroyed two buildings and three businesses, Ben Maxson rebuilt this structure and by 1916 was once again operating his hardware store along College Street. Maxson ran the store until 1934, and it was Holmes Hardware for many years after. The building became the home of American Awards and Promotions.

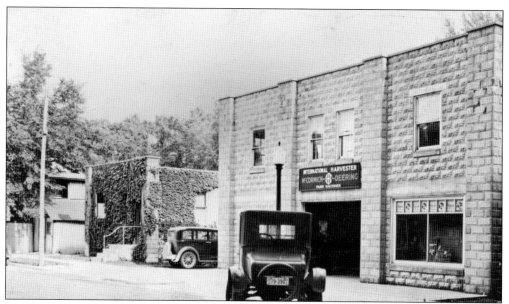

On the south side of College Street, across from the rebuilt Maxson building, was the implement dealership. At the time of this 1920s photograph, the dealership was operated by the Lipke brothers as a McCormick and International Harvester dealer. The Lipkes also erected many of the windmills in the Milton area at the time. This building later became the home of Captain Clean.

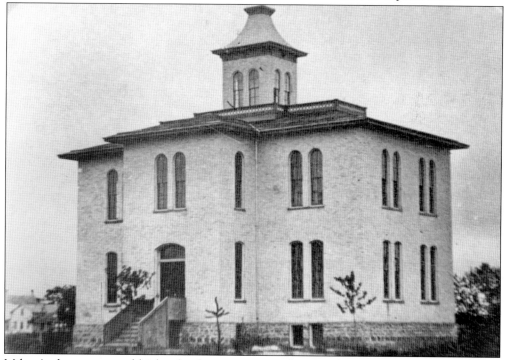

Milton's elementary and high school was constructed in South Goodrich Park in 1869. Ezra Goodrich drew up the plan and specifications for the school in 1867. Goodrich let the contract and personally supervised its construction. He laid out the park and school yard, and secured and set the trees and landscaping.

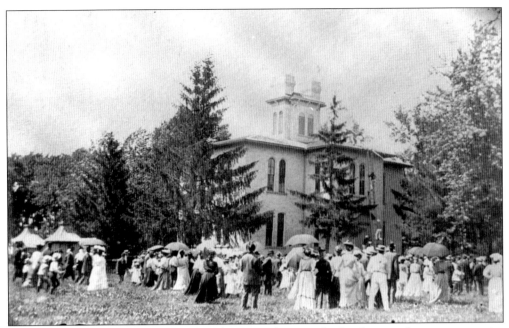

Following its construction in 1869, the school soon became the focal point of many community activities and functions. In the early 1900s, a large crowd gathered at the school to observe a demonstration by the fire department. The school served first through 12th grades until Milton Union High School was constructed in 1920. This is now the site of Milton East Elementary School.

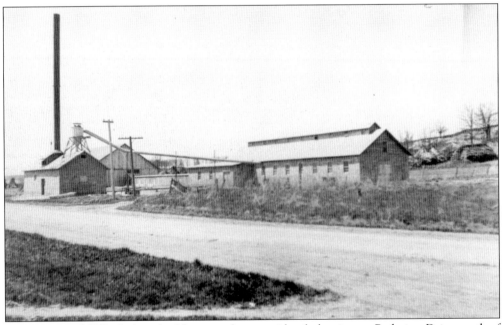

Following World War I, these buildings on the west side of what is now Parkview Drive south of St. Mary Church, owned by J.H. Burdick, were used as a hemp factory. Many of the workers were minorities and lived in the second floor of the Goodrich Block at the Milton House. Hemp was not raised extensively in the area, and the business did not last very long.

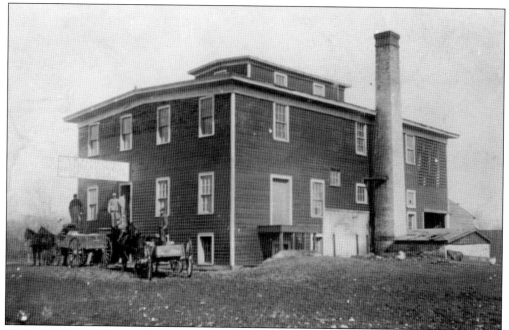

George R. Fetherston emigrated from Ireland to the town of Harmony in 1865 and purchased the Lane Mill in Milton in 1888. He operated Fetherston's Mill until 1924, when he moved to Whitewater and purchased the Old Stone Mill. Constructed as Union Flouring Mill in 1870, the mill was located at what became the corner of Plumb Street and Madison Avenue, where Jack Brown ran his oil business for many years.

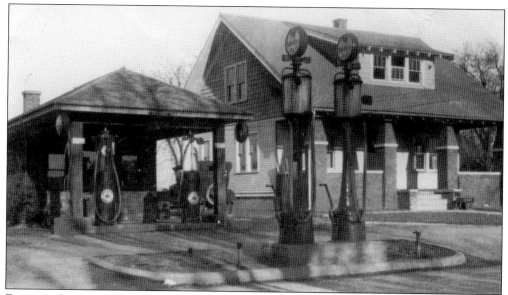

For several years, Carl Lubbe ran a service station along Madison Avenue where the villages of Milton and Milton Junction met. This brick house still stands at 102 East Madison Avenue. With gas pumps set in the terrace between the sidewalk and street, this is the first building east of what was once Tom's Restaurant.

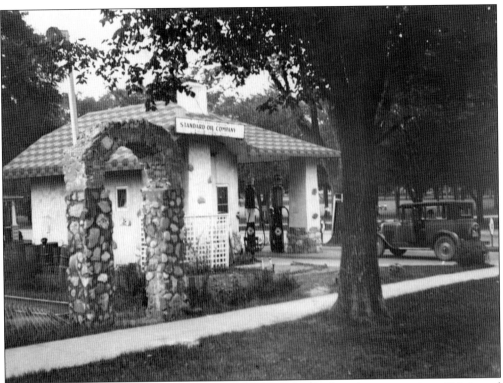

What became known as the Stone Arch Filling Station was built at the intersection of Main and High Streets in 1926 by Norris Rowbotham, who coached the Milton College football team in the late 1920s. This view is from High Street. The stone arch at this time led into a miniature golf course. The station has had many owners and operators, most recently Arndt's Mini Mart.

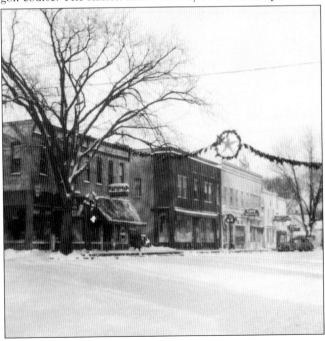

This winter scene from 1947 shows Main Street from College Street looking north with Christmas decorations strung high above the street. By the time of this photograph, the building between the J.P Bullis and the Dunn and Boss buildings had been constructed, filling in the south end of the Main Street block. The car is parked in front of the Power and Light office.

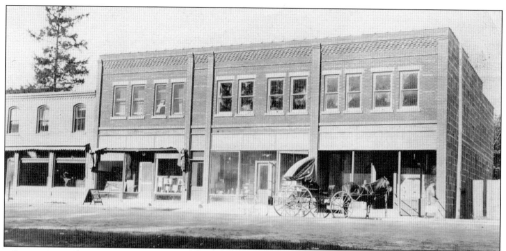

About the same time the Maxson building was completed along College Street in 1916, the Whittet Building, of similar brick and design, was built on the south end of Main Street adjoining the bank, at left. Walter Rogers ran an ice cream shop and confectionery in the section closest to the bank. W.W. Clarke ran a book and variety store in the center section, with the post office in the third section.

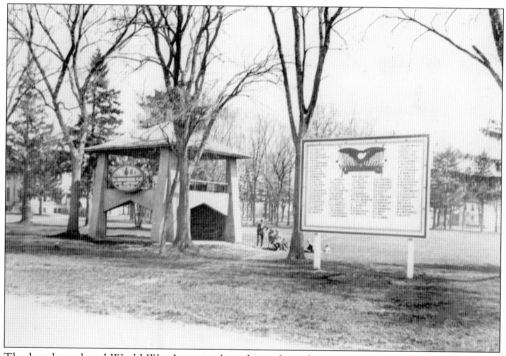

The bandstand and World War I service board stood on the west side of South Goodrich Park into the 1960s. The service board listed the names of area veterans who served in the Great War. The bandstand was used often for the many community gatherings that took place in the park, which hosted Fourth of July celebrations, baseball games, and other community events.

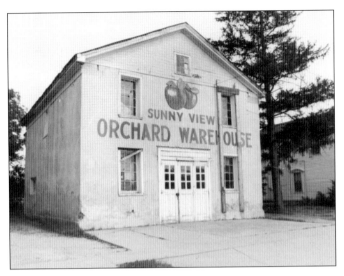

The Sunny View orchard Warehouse, located across Janesville Avenue from South Goodrich Park, is one of the original grout buildings constructed in Milton in the mid-1800s as a wheat warehouse. The building served as an apple warehouse through the mid-1900s. In the 1990s, it was deeded to the Milton Historical Society and then resold. It has since gone through extensive renovation and is the site of Northleaf Winery.

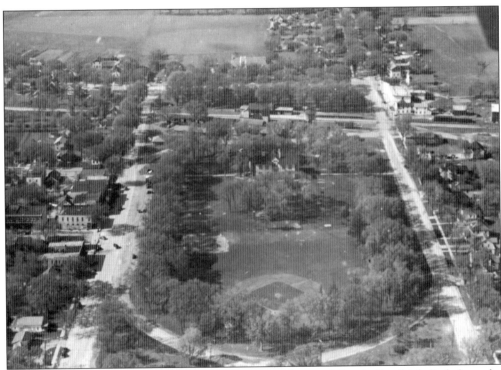

This is an aerial view looking north of downtown Milton and South Goodrich Park from the mid-1940s. The baseball infield is visible on the park's south end, and the grade school sits beyond center field. The Milton House complex is in the northeast corner of the photograph. To the west of the park is the Main Street business district.

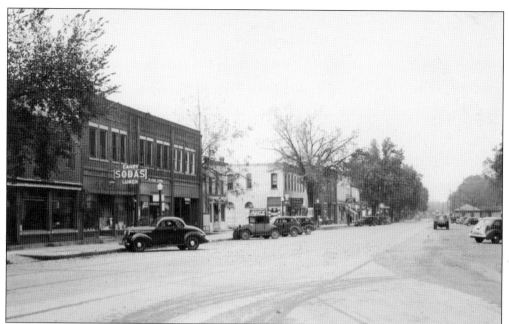

This view of Main Street looking north in the 1930s shows the Whittet Building in the foreground when Walter Rogers was running a lunch counter in the first section of the building. Later proprietors included Bob Bean, Bob Lyman, and Gil Gaines. The next store to the north was E-N-E Variety, operated by Elston and Emma Shaw. The post office occupied the next section of the building.

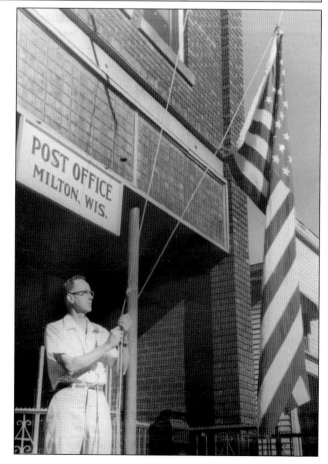

Chet Skelly was the co-owner of Sunny View Orchard and served as postmaster in Milton for 46 years. He is shown here lowering the American flag outside the post office when it was still located in the Whittet Building. In 1956, the post office moved to the north end of Main Street to a new brick building on the lot previously occupied by Ellery Burdick's Photograph Gallery.

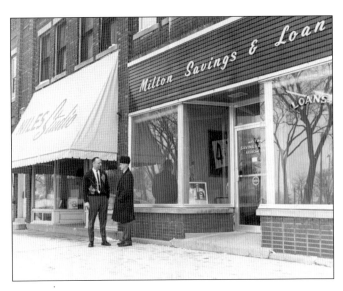

Once the post office vacated the Whittet Building in 1956, Milton Savings and Loan moved into the space from its office, which was located in the basement of the building since 1940. Milton Savings and Loan moved into a new building at the site of the former lumberyard in 1975. Niles Photography, which also had an Edgerton studio, was located in the adjoining storefront for two years beginning in 1964. Wayne Treder (left), president of the Savings and Loan, is shown chatting with Chuck Niles.

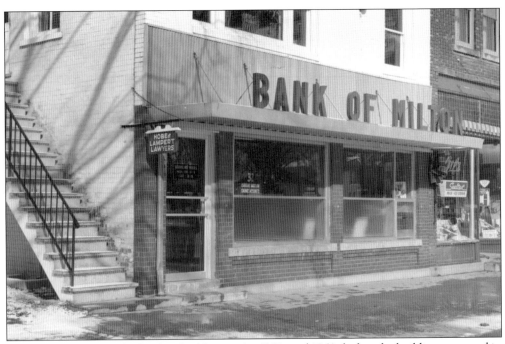

This is front of the Bank of Milton building in the 1950s and 1960s before the building was razed in 1973, when the new bank building was constructed on the adjacent lot to the south. The storefront next to the bank in this photograph was a restaurant operated by, among others, Bob Lyman and Gil Gaines. In the 1970s, it became Milton's first bar, the Parkview, and then the Cove.

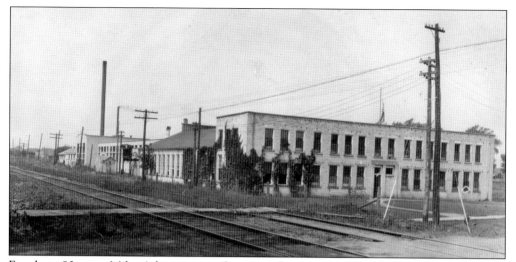

For about 80 years, Milton's largest manufacturing plant was the Burdick Corporation. This is a view of the factory from Plumb Street in 1925. Established in 1913 by F.F. Burdick, the company's first product was an electric light bath cabinet used for therapy by hospitals and health clubs. The company's growth was rapid during the 1920s, coinciding with the advent of ultraviolet and infrared therapy.

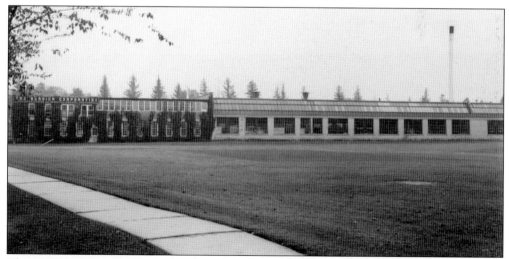

This 1935 view from Madison Avenue is how the Burdick Corporation facility looked about the time F.A. Anderson purchased controlling interest in the company. A wide range of Burdick medical electric instruments were manufactured at the facility and were common in hospitals, clinics, and doctors' offices. The company employed about 200 people through the 1970s. In the 1990s, the Siemens Company moved the operation to a new facility in Deerfield.

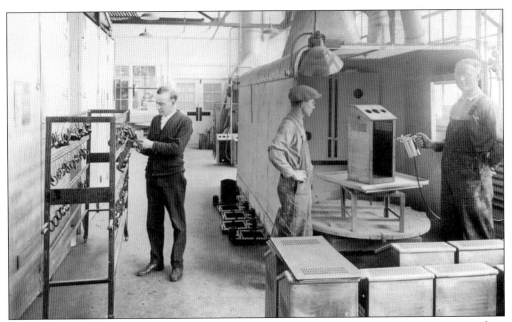

Paul Lemke (left) was foreman of the enameling department of the Burdick Corporation when this photograph was taken in the 1950s. Working with Lemke coating enamel onto cabinets for medical instruments are Carl Anderson (center) and Rye Baker. The Milton facility grew to nearly 100,000 square feet after renovations and expansions following World War II. Blackhawk Technical College now occupies the entire site.

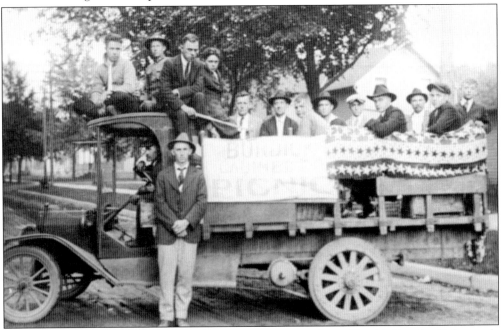

Burdick employees were often visible in the community, as evidenced by this Fourth of July parade entry around or before 1920. The five-day work week was a rule at Burdick Cabinet Company when it began operation in 1913. Henry Ford became famous for instituting the five-day work week at his Detroit automobile plant in 1914.

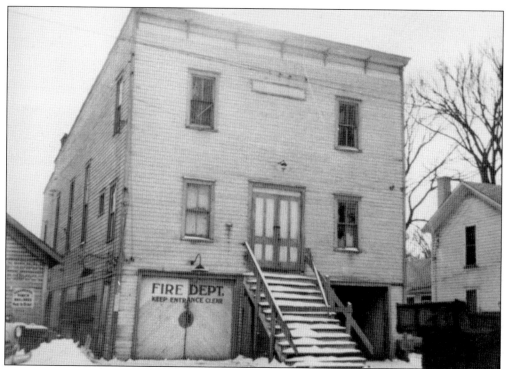

In 1907, the village purchased this hall from the Independent Order of Good Templars. Located on Greenman Street, the building served as the village hall and was used for a variety of gatherings. The top floor of the building was used by the We-Needa Theatre to show silent movies. It also housed the village fire equipment until the new city hall was built in 1955, and this building was razed.

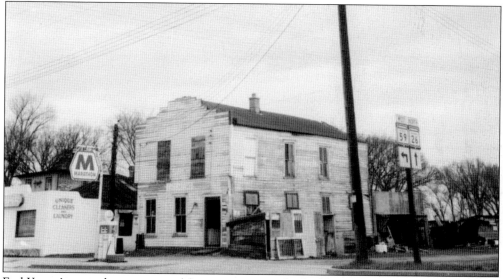

Earl Young's general store operated for many years in this building, which was built in the 1870s as a hotel at the south end of the Milton House Goodrich Block. The building was razed in the mid-1960s, and a Dog 'n Suds drive-in was located there. Just to the north of Young's was Unique Cleaners, a dry cleaner that operated out of the old blacksmith shop.

Elwood and Madge Shumway began their appliance shop in the south section of the Ellery Burdick Gallery in 1926. Shortly after World War II, they moved the business to this building on the north corner of Main and Greenman Streets. Many of the early televisions, hi-fis, and kitchen and laundry appliances sold in the Milton area came through this building. The business moved to a new facility in 1975.

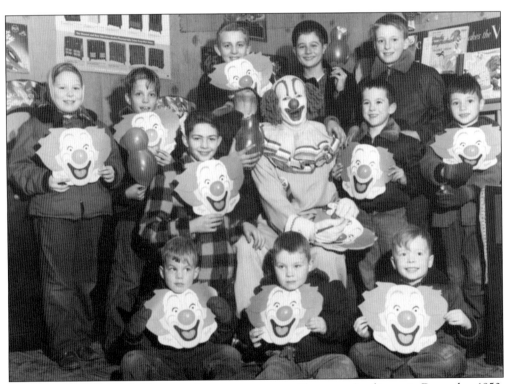

Bozo the Capital Records Clown made an appearance at Shumway Appliance in December 1950. Some of the children on hand to meet Bozo are, from left to right, (first row) David Bowen, George Cashore, and Milton Davis Jr.; (second row) Judy Werfal, Bobby Moberly, Roger Shadel, Bozo, Danny Moberly, and Wayland Bauer; (third row) Jerry Bean, Rob Thornberry, and John Werfal.

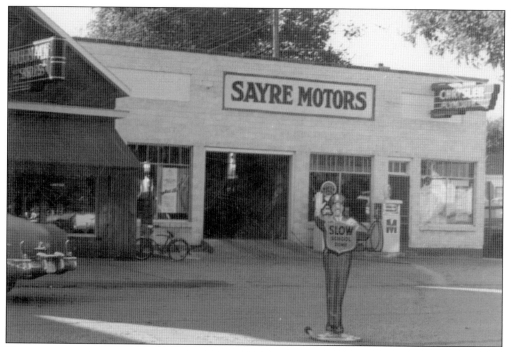

The crossing guard outside of Sayre Motors on Main Street in 1960 was a stationary fellow. The Sayre Motors building was constructed at the corner of Greenman and Main Streets in 1926. For many years at this location, Walt Sayre dealt Chrysler and Plymouth automobiles, sold gasoline, and ran the school buses for the School District of Milton. The building to the south of Sayre was Hutter Shoes.

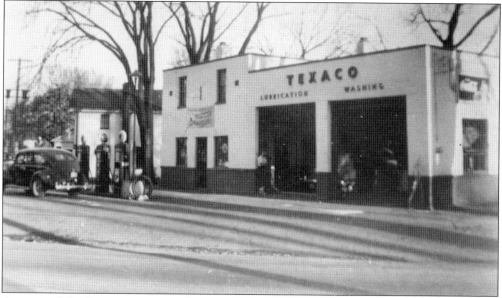

As automobiles became more popular, service stations began popping up on almost every busy corner of the village. This is a mid-1930s view of the Texaco station at the intersection of High Street and Parkview Drive, kitty-corner from the Stone Arch station. The station had many proprietors, most notably Jerry Frailey's Pure Oil through the 1950s and into the early 1970s.

This nice winter scene from South Goodrich Park in the 1950s shows a pine tree that was often decorated for Christmas in the foreground and the holiday lights along Main Street. Sayre Motors can be seen on the left, with Shumway Appliance the next building north.

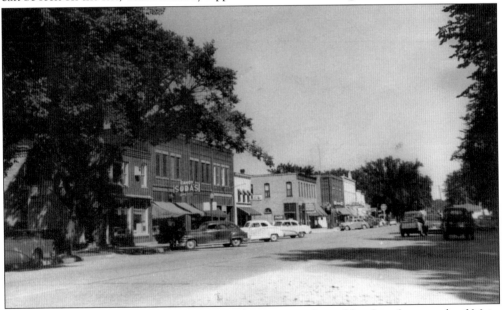

The 1950s were a busy time for Milton merchants, as evidenced by this photograph of Main Street, which became Parkview Drive once the villages of Milton and Milton Junction merged into one city in 1967. The photograph shows the wide range of colorful electric signs that hung outside most of the businesses.

Three

MILTON JUNCTION

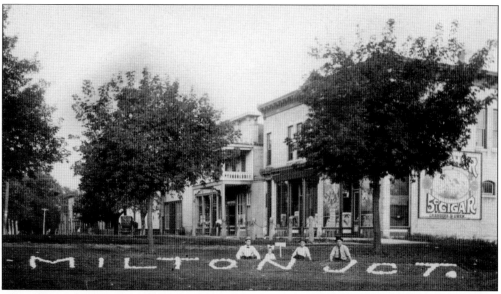

The village of Milton Junction grew around the crossing of rail lines established in the 1850s. Through the second half of the 1800s, Milton Junction became a rail hub of Southern Wisconsin where north and southbound rail traffic could turn east toward Milwaukee. Some 30 to 50 trains came through the junction daily. This sign greeted rail riders and was the view from the platform of the Morgan House hotel and depot around 1910.

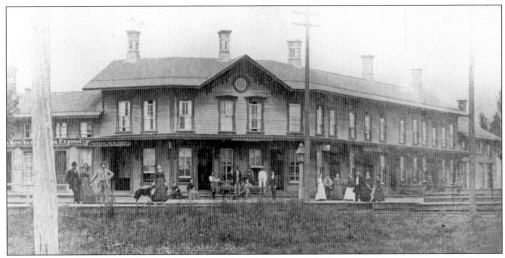

As rail traffic through Milton Junction increased, the need for hotel and travel accommodations did as well. William Morgan built the Morgan House in 1861 at what is now the intersection of Elm Street and Merchant's Row. Pictured here in 1965, this first incarnation of the Morgan House was destroyed by fire on Christmas Eve 1872.

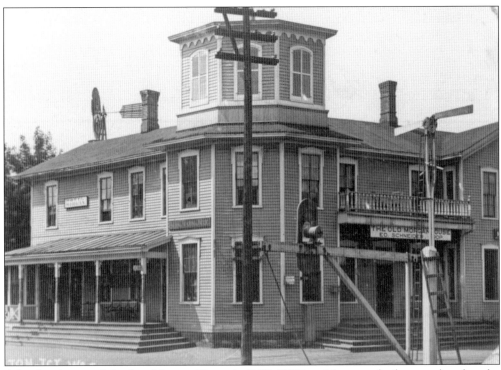

After fire destroyed the first Morgan House in 1872, William Morgan rebuilt a new hotel at the same location. It operated for several years under about a half-dozen different proprietors before being razed in 1923. The Morgan House also served as the village train depot. The building was replaced by a smaller depot, which was eventually converted to the popular restaurant Liberty Station, and later, Klig's Union Depot.

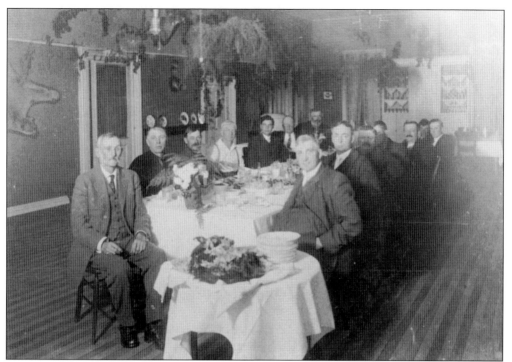

This is the Morgan House dining room in about 1910. Gathered here are several Junction business owners of the day. Clockwise from left are Phil Cole, Will Klitzkie, Wes Stockman, Will Williams, Chapin Hull, Lyse Miller, C.M. Garthwaite, Hugh McDonall, George McCullock, Ed McGowan, Archie Cullen, and Will Wall.

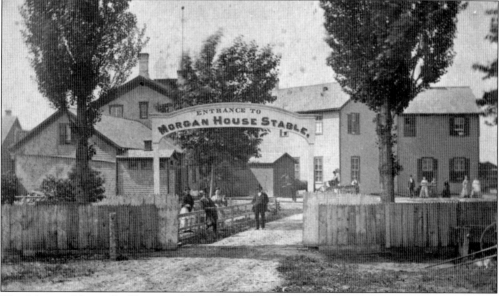

The Morgan House Stable was a busy place when this stereoscope photograph was taken in the 1880s, and top hats were all the rage. The stable barn was said to be located west of the Morgan House, most likely in the vicinity of what later became Liberty Park and the area of the water tower.

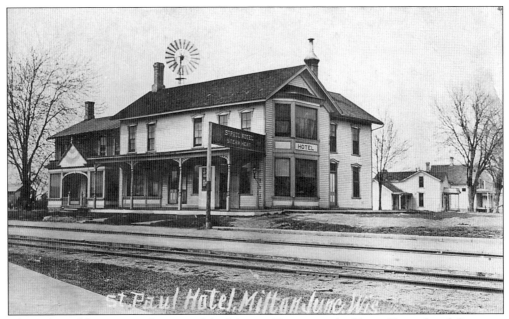

Along the rail line just to the west of the Morgan House was the Foster House hotel. It was in later years the St. Paul Hotel and featured a ballroom that attracted local residents for music and dancing. This hotel stood longer than the Morgan House and was razed in the 1930s.

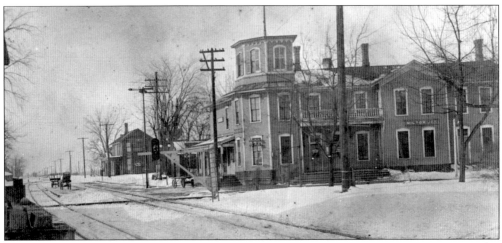

This view looking west shows the St. Paul Hotel just beyond the Morgan House on a snowy day in the early 1900s. The rail line running north and south was eventually abandoned and torn out. It was replaced in this vicinity by what became Elm Street, which connected with Merchants Row and Vernal Avenue.

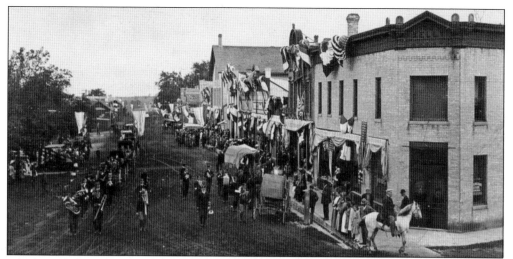

Popular and common postcards from the early 1900s were elevated views of parades and festivals held in Milton Junction's downtown. This is a view from the Button Building looking north during the Milton Junction High School's homecoming parade in 1911. The Kelly Block is the large building in the right foreground, and the tallest wooden structure down the block is the Patrons of Husbandry (P of H) Hall.

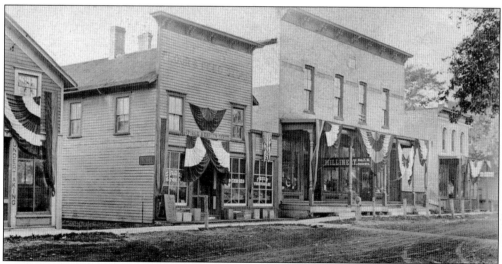

Businesses at the west end of Vernal Avenue are decked out in bunting and other decorations for the 1911 homecoming parade. The wooden structure on the left was a feed and garden store. The middle building was a millinery operated by Mrs. F.M. Roberts. Later, the building was the home of Albrecht Funeral and Furniture for many years. The end building on the right was a newspaper office and print shop.

The Vernal Avenue building that has housed Milton's newspaper for more than a century was built in 1888. Orlando Frantz bought the paper from Edward Holston in 1919 and sold it in 1946 to F.A. "Bud" Bowen. Mike Flaherty owned the *Courier* for 30 years, until 1991, and then Doug Welch served as its managing editor for 21 years. Susan Angell became the newspaper's first woman editor in 2014.

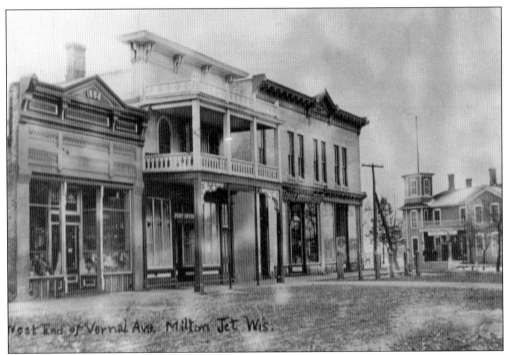

This is a rare photograph showing the Morgan House in relation to the businesses and the Button Building at the end of Vernal Avenue and Merchants Row. The west end of the Button Building was the home of Chamber and Owens. The post office was located on the ground floor until 1913. The balcony was a popular place to photograph many of the parades and festivals hosted in Milton Junction.

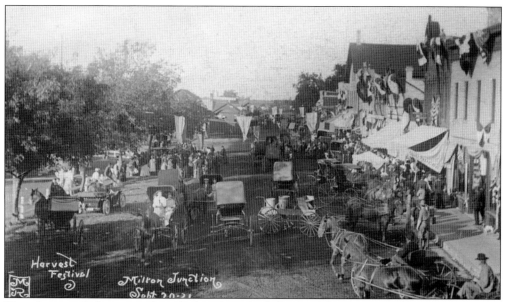

This photograph facing north and taken from the balcony of the Button Building in 1911 shows the popularity of Junction's bustling harvest festival each year. Horses, carriages, and at least one horseless carriage crowd Merchants Row on this bright September afternoon, and many merchants display their wares on the front sidewalks.

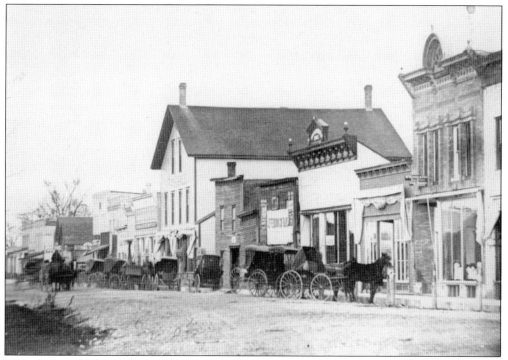

This photograph shows the south end of Merchants Row in the late 1800s when horse and buggies were the preferred mode of transportation. Most of the brick and concrete buildings on this end of the street had yet to be built. The tallest wooden structure is the P of H Hall, also known as the Grange Hall.

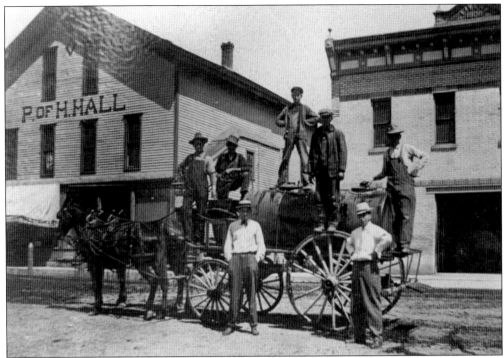

Street sprinkler crews were a common sight on village streets through the 1920s, when the street surfaces were gravel and dirt. The crew is stopped outside of the P of H Hall, at a time when the building was still in pretty fair shape. Constructed in 1866 by Isaac Morgan, the three-story building was purchased by the Grange in 1881.

The creamery at the north end of Merchants Row did a brisk business for many years. In 1895, A.D. Conkley purchased a tract of land adjoining the railway and erected a creamery in which he could make butter on a large scale. He sold the business to James Campbell in 1900. A cooperative creamery operated there for many years, and the Badgerland Co-op service station eventually occupied this site.

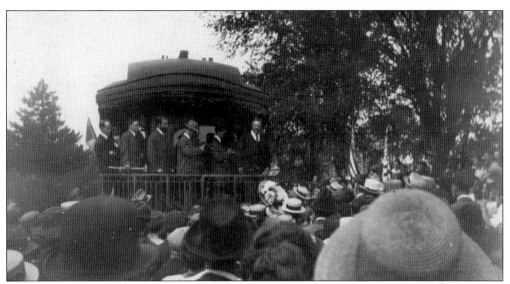

Former president Theodore Roosevelt drew quite a crowd in Milton Junction when he spoke from the back of a railcar in September 1910. Roosevelt had concluded eight years in the White House the previous year. He remained active in politics, seeking the Republican nomination for president in the 1912 election. When the party nominated incumbent William Howard Taft, Roosevelt mounted an unsuccessful run under the Bull Moose Party.

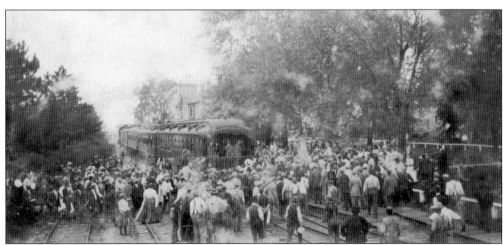

Junction residents swarmed to the back of the train carrying Theodore Roosevelt in September 1910. This area is to the rear of the businesses along Vernal Avenue. The top of the Morgan House can be seen in the upper right. The photograph also shows the number of tracks and spurs at the time as well as a wooden platform at the side of the tracks.

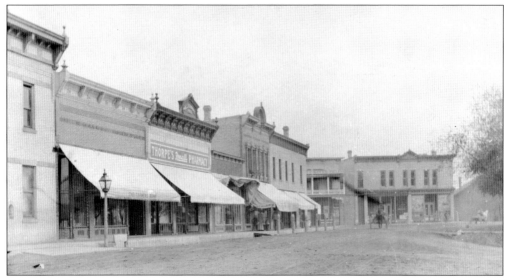

A horse and buggy may still have been a common mode of transportation, but the south end of Merchants Row was taking a more modern shape by 1915. The Thorpe Pharmacy building was built in 1906 and the Farmer's Bank building in 1911 by John A. Paul Sr.

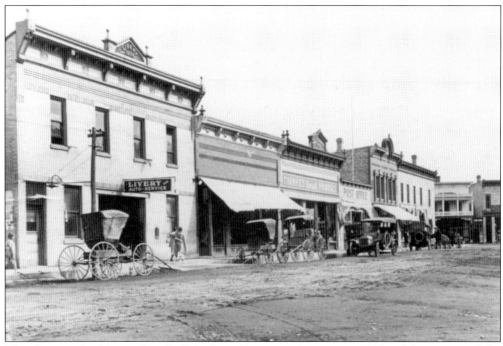

This photograph of the south end of Merchants Row was taken prior to 1920 and shows automobiles beginning to mix in with horses and buggies. The post office moved to this location from the Button Building in 1913. Another sign of the changing times is the fact that the livery advertised auto service.

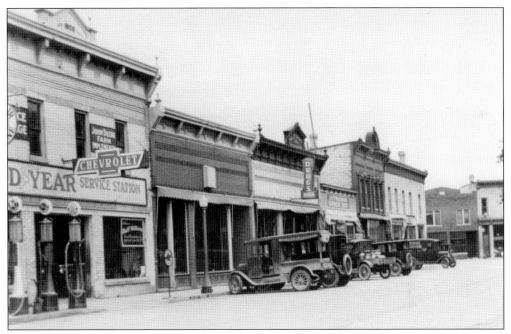

Gas pumps sprang up in front the building that formerly housed the livery by the time of this mid-1920s photograph. The livery began transitioning to an automobile service garage in 1918. It was a Chevrolet dealership at this time, and later Desens Ford. Dickoff Chevrolet was the last to use the space as a showroom up to the early 1960s, when the building was purchased by the bank.

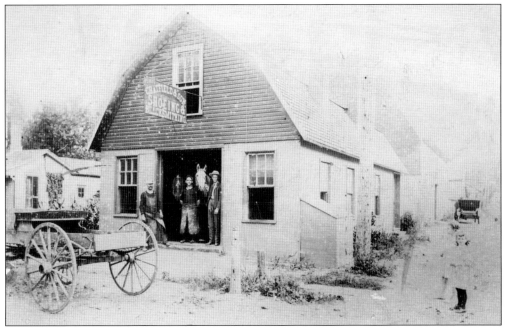

George Chatfield built this blacksmith shop along Crandall Street, about a block east of Merchants Row, in 1903. He carried on blacksmithing there for several years, followed by Lou Lumm. The building is on Crandall Street at the alley that runs behind the Merchants Row businesses, and housed a tool and die business in the 1970s.

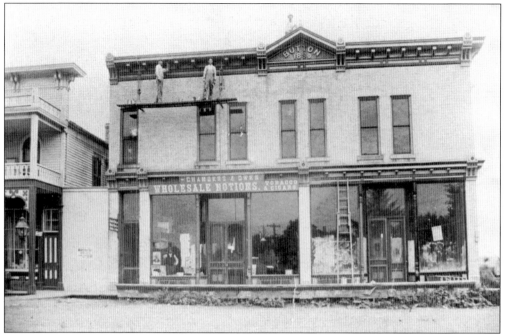

George Button, who operated a cigar factory for many years, erected the building that stands at the west end of Vernal Avenue and the south end of Merchants Row in 1890. He died the following year. Stewart Chambers and John Owen formed a partnership to use the building to sell wholesale tobacco products and grocery necessities. Chambers and Owen still operates in Janesville. This building now houses Milton Family Restaurant.

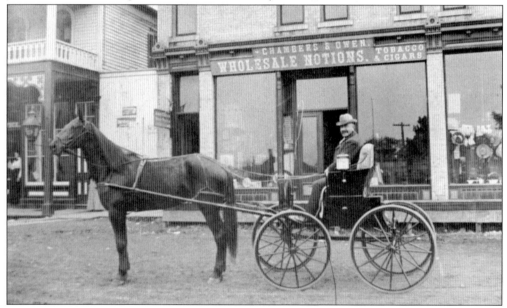

Stewart Chambers partnered with John Owen to form Chambers and Owen, jobbers of notions and cigars. John Owen was the brother-in-law of George Button, who constructed the building at the south end of Merchants Row where the business began. Stewart Chambers is shown here in a horse and buggy outside the business in the early 1900s.

Stewart Chambers built one of Milton Junction's landmark homes in 1911 at the corner of Madison Avenue and John Paul Road for $15,000. The Queen Anne–style home, shown here in the early 1960s, had all of the modern conveniences of the time, including a laundry room, fuel room, ash room, and root cellar. The house was wired for electricity in the event electric power became available in the village.

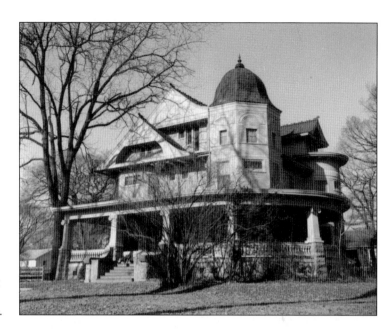

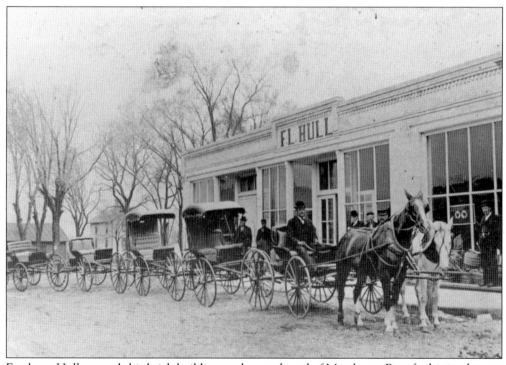

Freeborn Hull erected this brick building at the north end of Merchants Row for his implement business in the early 1900s. Hull was born on a farm near Otter Creek. He worked for his father in the hardware business before opening his own implement store. After he retired from the business, the building was used as an automobile dealership for many years, most notably Dickoff Chevrolet.

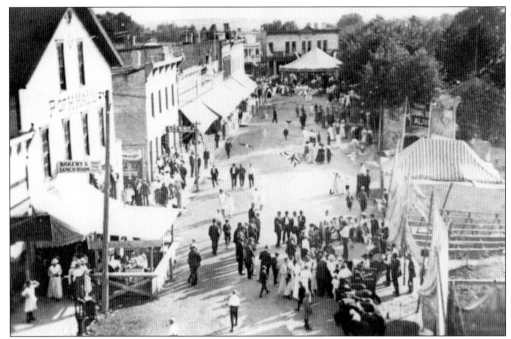

This unique view of Milton Junction's annual harvest festival in 1917 was likely taken from the top of a Ferris wheel. Tents and attractions line both sides of the street, including a stand in front of the P of H Hall on the left and what appears to be a merry-go-round at the end of the street.

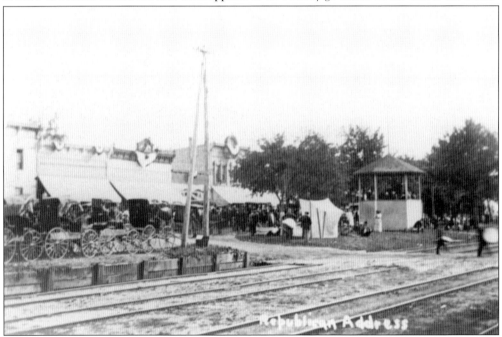

This photograph, simply labeled "Republican Address," was taken from across the north-south rail tracks facing east, perhaps around 1915. The tops of Merchant Row buildings and awnings can be seen beyond the line of buggies. A large crowd is gathered around the bandstand that once stood in Railroad Park.

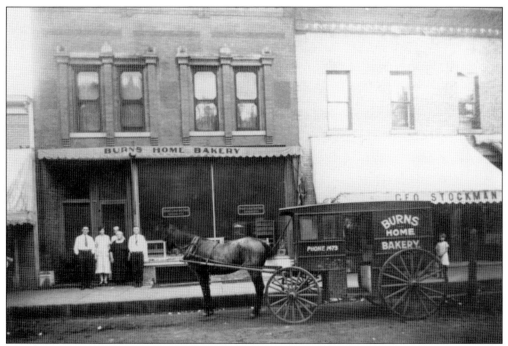

The Burns family operated a bakery for a number of years in the early 1920s in the building next to the Kelly Block on the south end of Merchants Row. Mike Burns Sr. (right) moved the business around the corner to a building on Vernal Avenue. In the spring of 1926, that frame building burned, and Burns died when he was frying donuts and grease boiled over.

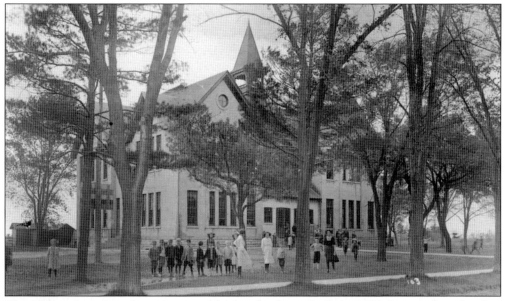

The Milton Junction elementary and high school was built in 1889. It served grades first through 12th until the Milton Union High School was built along Madison Avenue in 1920. A single-story addition was attached to this building in 1960. January 1968 saw the old Junction school razed and plans completed for the second building phase of what became Milton West Elementary School.

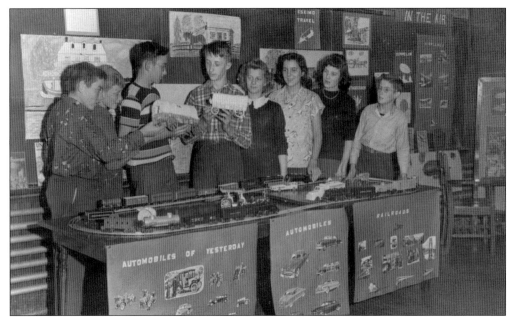

Eighth graders attended the Junction school until the new high school was built in 1965, and the old Union High School converted to a junior high. In 1949, these Junction eighth graders show off their project on the evolution of transportation. From left to right are Dick Osborne, George Astin, Dale Krueger, Donald Clarke, Beverly Schultz, Elaine Kumlien, Lilia Manogue, and Leo Manogue.

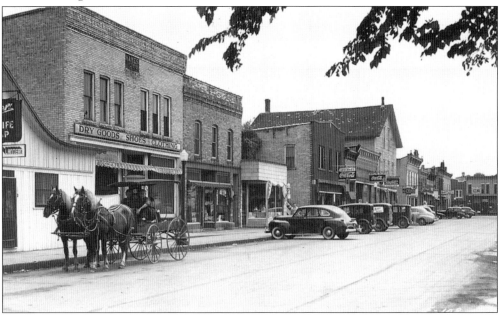

Horse and buggies were a rare sight along Merchants Row in the 1940s. The Green Lantern Tavern is the white building on the left, next to the Hayes Block. Half of the Hayes was a dry goods and dress shop of Ruth Conroy and the other half Einerson's Men's Clothing. From 1962 to 1967, a Ben Franklin store occupied the space. In 1969, Ken and Kay Demrow purchased the building and opened the Olde Towne Inn.

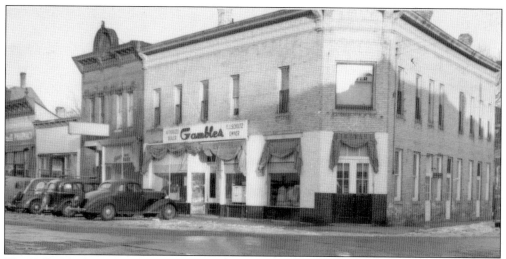

The Kelly Block, at the corner of Merchants Row and Vernal Avenue, had originally been the site of a boardinghouse and grocery when David Kelly built the angular structure in 1897. Fred Schultz ran the Gambles hardware and department store at this location in the mid-1940s.

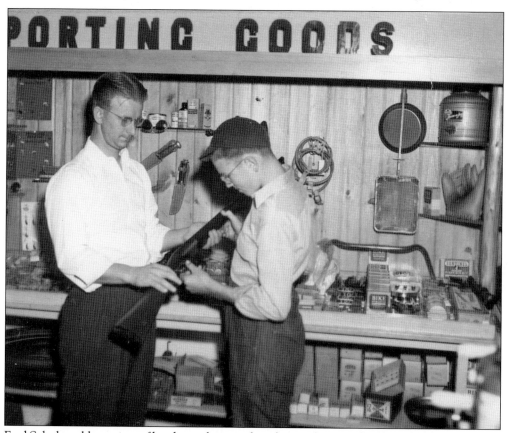

Fred Schultz sold a variety of hardware, lawn and garden products, and tools in the Gambles store. In this 1946 photograph, which appeared as part of a business feature on the front page of the *Milton Courier*, Schultz is showing a firearm to Jack McVicar in the sporting-goods department.

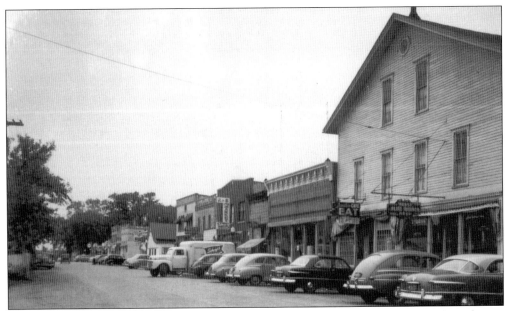

The mid-block of Merchants Row facing north in the early 1950s sported more modern electric store signs, but the 90-year-old P of H Hall was still a dominant figure along the street. The building was the home of the Grange Hall as well as a café and The Spot tavern.

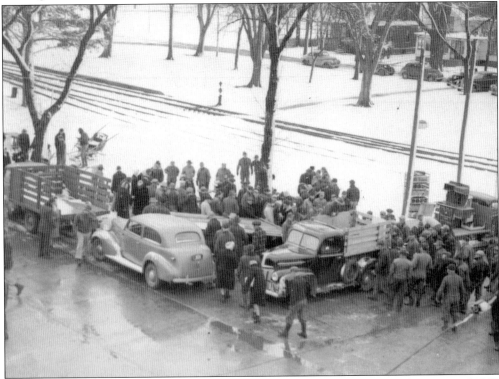

This is an elevated view of a community auction on Merchants Row during the winter of 1947. This shot was likely taken from one of the upper floors of the P of H Hall and shows the many rail tracks and spurs that were in use between Merchant's Row and Front Street.

Community auctions were a staple of downtown Milton Junction from the time the Grange organization purchased Morgan Hall from Isaac Morgan in 1881. The Grange was a national agricultural organization with strong Wisconsin chapters beginning in the late 1800s. Col. Charles Thayer is shown here conducting a Grange auction in 1947.

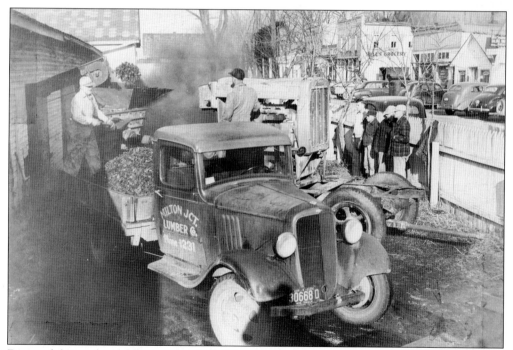

Demand for coal on this morning in 1950 emptied the bin of the Milton Junction Lumber Company. Local contractor Leo Frank set up his company's stone crusher to assist the lumber company with processing larger chunks of coal. Paul Ronde is manning the shovel, and Frank and Paul Wendt are among the onlookers.

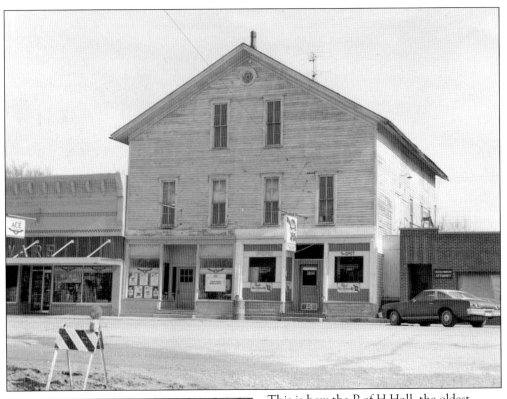

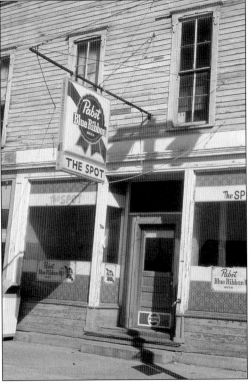

This is how the P of H Hall, the oldest building on Merchants Row, looked right before it was razed in 1975. Built in 1866 by Isaac Morgan, it housed hardware stores, general stores, bakeries, and restaurants. During its final days, one half of the ground floor was The Spot tavern, and the other half was storage for Hillestad's Ace Hardware.

The Spot tavern was a popular watering hole at a time when Milton Junction issued liquor licenses for taverns and restaurants and the Milton end of town did not. It was a colorful place that often mixed card-playing farmers and laborers with rambunctious students from Milton College. When the building was razed, owners Gordy and Jean Jones moved the tavern a block north to the vacated post office building.

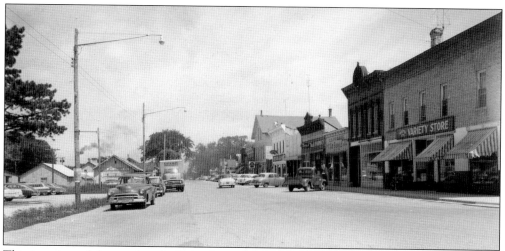

This is a view of the south end of Merchants Row in the mid-to-late 1950s looking north. The Milton Junction Variety Store was located in the Kelly Block where Gambles hardware had been. Chet Strassburg's clothing store was in the next building, and the Farmer's Bank was wedged between the drugstore and the Ford dealership.

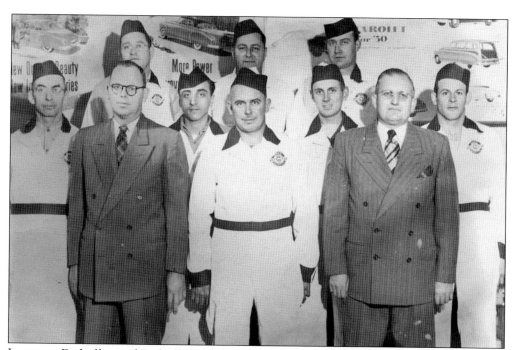

Lawrence Dickoff owned Dickoff Chevrolet on the north end of Merchants Row until he passed away in 1974. He became the city's first mayor when the villages merged in 1967. Pictured here is the Dickoff Chevrolet staff in 1950. From left to right are (first row) Tom King, Edwin Kunkel, and Lawrence Dickoff; (second row) Henry Ullius, Leonard D'Angelo, Charles Johnson, and Ray Budde; (third row) John Murphy, Burl Olson, and Fred Zinn.

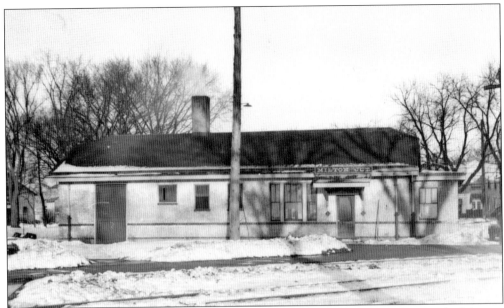

In the early 1920s, members of the Milton Junction Fortnightly Club, believing the Morgan House should be replaced as a rail depot, sent a delegation to Madison to present a petition to the Railroad Commission for a new depot. In 1923, the Morgan House was razed and a new depot built. This is how the depot looked in 1945 in a view facing east with the Merchants Row buildings in the background.

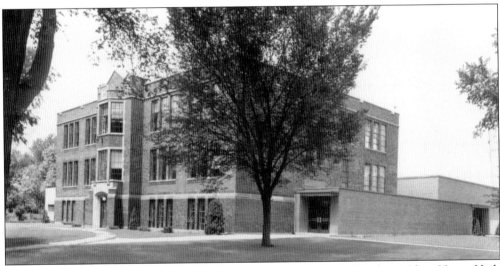

High school students no longer attended the Junction school after 1920, when Milton Union High School was built along Madison Avenue. This is a view of the school shortly after the gymnasium addition was constructed in 1953. The gym addition still stands after the remainder of the school was razed in 1980 and replaced by the district's middle school.

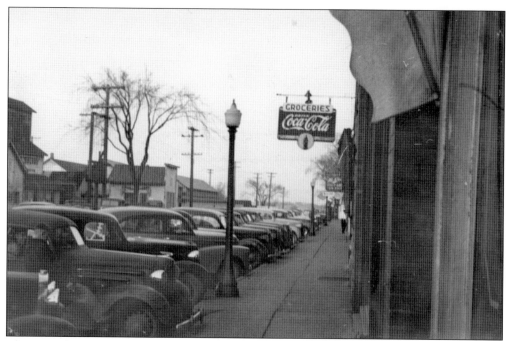

This street-level view of Merchants Row facing north was taken in the late 1940s from just north of the P of H Hall. The photograph shows the lumber yard buildings on the west side of Merchants Row and the Miller High Life sign that hung down the street outside of the Green Lantern.

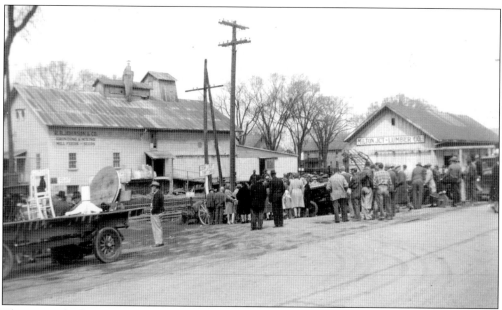

This view of a Grange auction facing northwest along Merchant's Row shows the feed mill across the railroad tracks and the Milton Junction Lumber Company. Ross Johnson owned the mill at the time of this 1940s photograph. Johnson sold the mill to Farley Feeds in the 1960s, and it was later sold to Gerald Arndt, who used it as an office for Milton Propane.

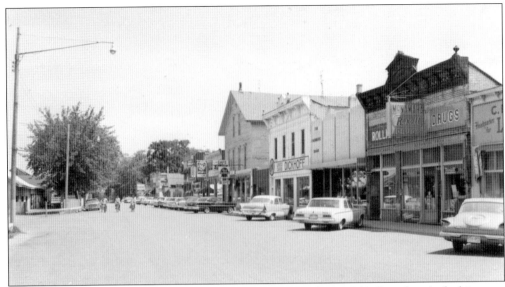

This view looking north along Merchants Row was taken about 1964. Strassburg's clothing was still in the white brick building, and Dan Mc Namara had taken over the Rexall Pharmacy. Dickoff Chevrolet had moved into the building previously occupied by the Ford dealership and used it as a showroom for several years.

Here is another look at the Milton Junction sign from the platform of the Morgan House hotel and depot in about 1910. The banner signs advertised an upcoming harvest festival, which featured "3 Big Free Attractions, Races, 6 Games." Also highlighted in the photograph are the many trees that shaded what became Railroad Park and the walking path that led to the depot from the front of the Vernal Avenue businesses.

Four

WORKING RAILS

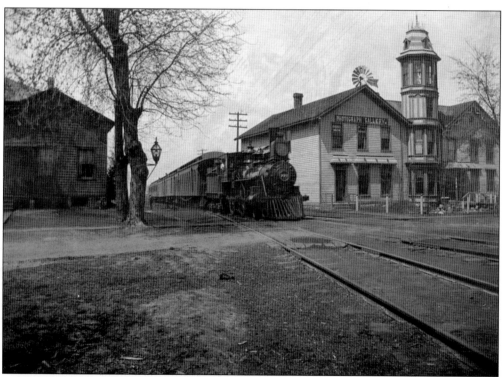

For the better portion of a century, from the late 1850s through the early 1950s, locomotives were a common element on the Milton and Milton Junction landscape. As many as 30 to 50 trains came through the twin villages daily when rail traffic was in its salad days of the late 1800s and early 1900s. This photograph captures a locomotive passing the Ellery Burdick Photograph Gallery in Milton.

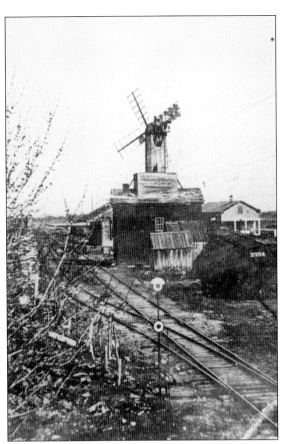

Once the first train pulled into Milton in 1852, it forever changed the business and cultural landscape of the village. This is an early image of the first train depot erected by the Milwaukee and Mississippi Railroad on the south side of the tracks next to what is now North Goodrich Park near the Milton House. Visible in the background is James McEwan's store, which burned in 1898.

This photograph taken in the early 1860s from the elevated grounds of Main Hall illustrates how the first depot's unique windmill dominated the village of Milton's landscape. Behind the depot is the Milton House, in the only known photograph that shows the inn's hexagon as a two-story structure. The third floor of the inn was added by Ezra Goodrich in 1867.

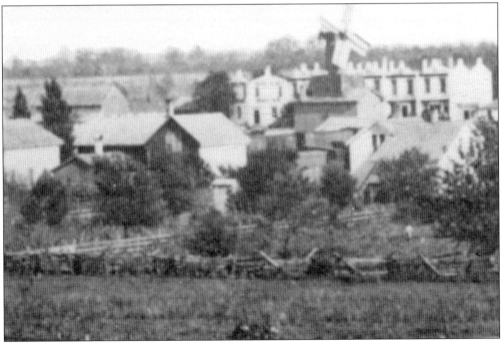

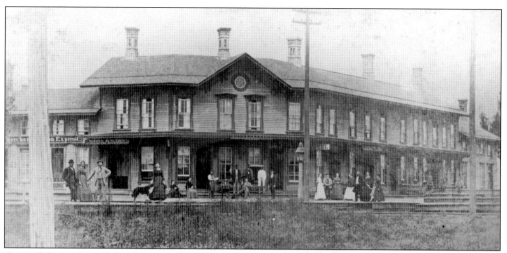

One of the early rail depots in Milton Junction was the original Morgan House, built in 1861 by William Morgan. This photograph was taken around 1865, about seven years before the hotel and depot burned to the ground on Christmas Eve 1872. Morgan rebuilt at the same location—now near the intersection of Elm Street and Merchants Row—and was back in business the next year.

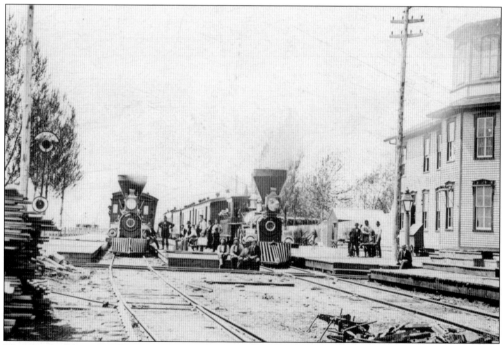

These wood-burning locomotives were stopped near the rebuilt Morgan House in 1879. The trains are facing east, and the photograph shows the trains' crews taking a lunch break on the platform that separated the two tracks at the time. Wood-burning locomotives were common in the United States through the 1870s, gradually giving way to coal-fired boilers.

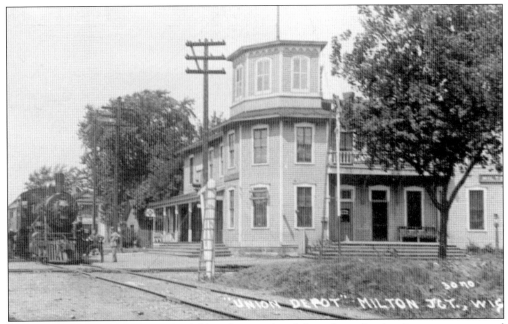

The rebuilt Morgan House served as Milton Junction's rail depot from the time it was reconstructed following the 1872 fire until the large building was razed in the early 1920s. In this photograph, a couple of railroad men pose outside of a stopped eastbound train sometime in the early 1900s.

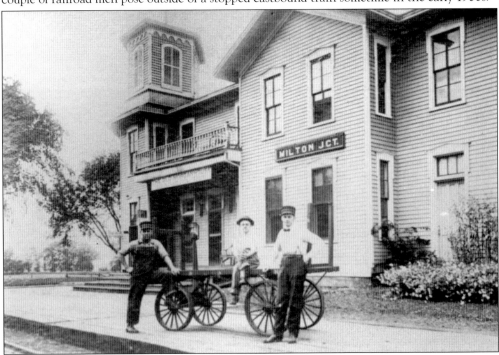

Rail workers pose outside the Morgan House on the east-facing platform with a freight cart in the early 1900s. The angular structure served as a depot and hotel with a large ballroom. William Morgan sold the building to his son-in-law John C. Stetson in 1878, six years after rebuilding and one year after his daughter, Minnie (Stetson's wife), passed away.

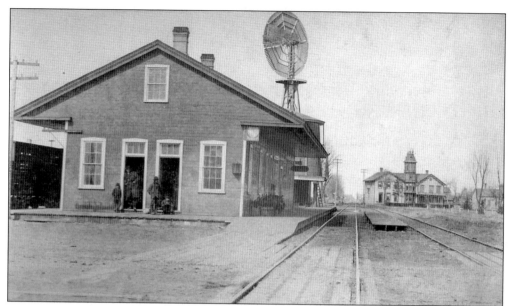

The Milton depot was located on the south side of the railroad tracks until it burned to the ground in September 1913 due to a lightning strike. Visible in this photograph, facing west, is the windmill that pumped water into the elevated tank. Down the tracks to the right is the Ellery Burdick Photograph Gallery, located at what is now the intersection of Parkview Drive and Madison Avenue.

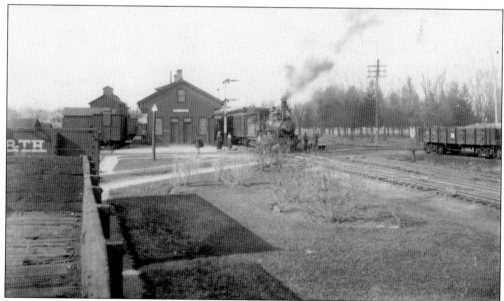

This image was scanned from a glass negative and shows an eastbound train getting ready to depart the Milton depot sometime in the late 1890s. Two women walk toward the camera. To the right, the pine trees that Ezra Goodrich planted in the park in 1879 are reaching maturity.

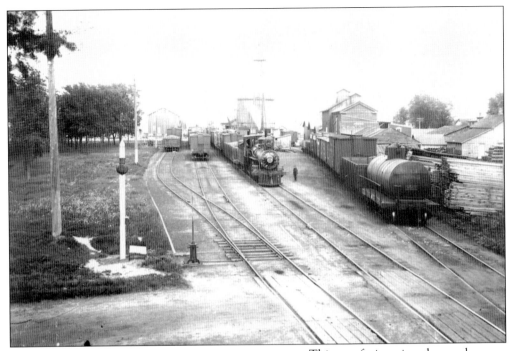

This east-facing view shows a busy Milton switchyard in a photograph that was likely snapped from an upper floor of the Ellery Burdick Photograph Gallery. Along the south side of the tracks in the foreground is the lumber yard of T.A. Saunders, who began operating the business in 1890. The photograph was taken prior to the depot being destroyed by fire in 1913.

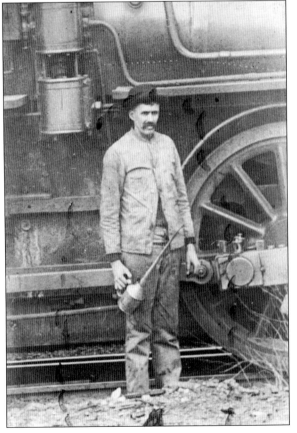

Ellery Burdick's gallery was a unique landmark in the village of Milton for many years. Burdick was responsible for many of the Milton-area portraits that were taken from the 1870s until his death in 1919. This portrait of a railroad engineer is an example of Burdick's work.

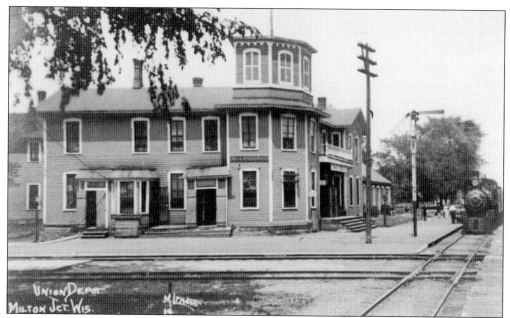

UNION DEPOT
MILTON JCT. WIS.

The north-south rail line through Milton Junction, shown here with a southbound train stopped outside the Morgan House in the early 1900s, was abandoned and torn out in the 1970s. While the line was in use, there was no street that connected Elm Street with Merchants Row and Vernal Avenue. The rail and boardwalk seen in the foreground of this photograph were replaced by the connector street.

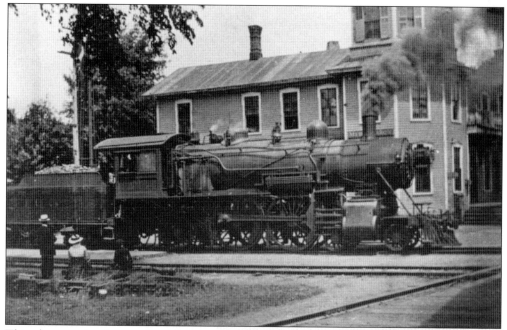

This photograph of an eastbound train chugging past the Morgan House in the early 1900s is a reminder of the dirty black smoke that belched from the coal-fired locomotives of the day. Even though 30 to 50 trains per day rolled through the village, people still stopped to watch the steel behemoths do their work.

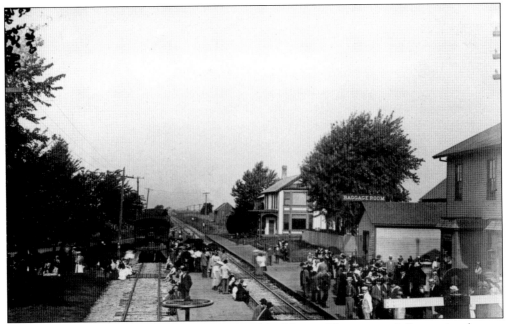

Crowds could often be seen gathering outside of the Morgan House, especially on nice days, as people waited for the next train to come along. This view looking west shows people waiting outside the Morgan House as well as on the between-the-rails platforms. The St. Paul Hotel is visible down the track.

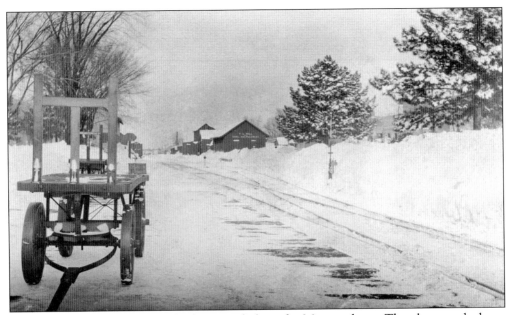

This view from January 1910 is looking north from the Morgan depot. The photograph shows the tops of the Merchant Row buildings peeking over the snowbank on the right. The F.L. Hull building was where the lumber yard was eventually located. Freeborn Hull used this building at the same time he operated his implement business in a new building on the north end of Merchants Row.

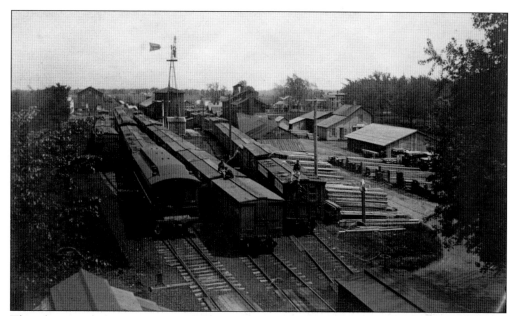

This photograph facing east was likely taken from the tower of the Ellery Burdick Photograph Gallery and shows the Milton switchyard on a busy day prior to 1913. Four rows of train cars were in the yard that day, and rail workers were on the roof tops of a couple of cars. T.A. Saunders's lumber yard is to the south of the switchyard.

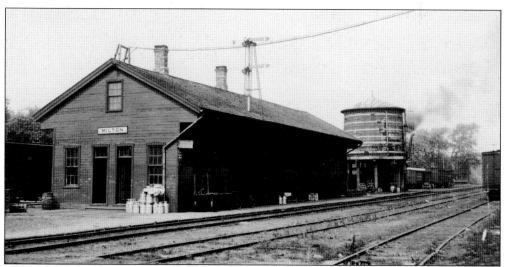

This is one of the last images of the Milton depot, taken before it was destroyed in a 1913 fire. Facing southwest, the photograph shows the east end of the building with several milk cans stacked on its platform. The depot's large elevated water tank is at the west end.

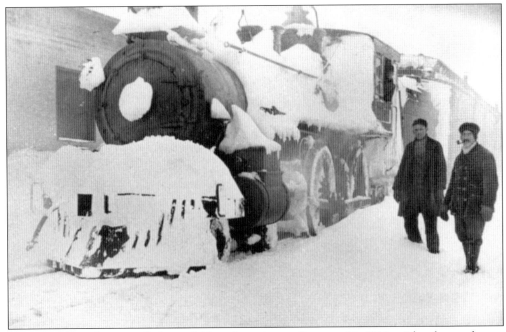

This southbound train rolled into Milton Junction on January 14, 1910, with a layer of snow and ice thick enough to seemingly chill the locomotive itself to the bone. Record snow fell in southern Wisconsin in 1910 and made for some photogenic views of how locomotives and rail crews dealt with the elements.

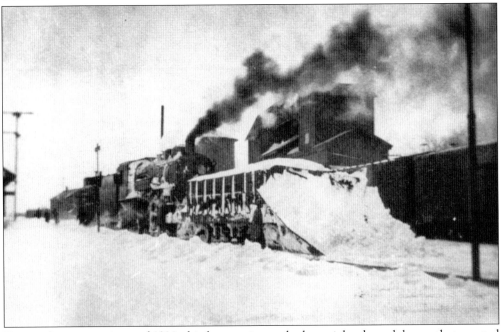

During the snowy winter of 1914, this locomotive pushed a weighted gondola car that sported a plow mounted on one end. The westbound locomotive is sitting for water at the Milton depot while its stack belches black smoke. This image graced a popular postcard at the time that was simply titled "Looking for Trouble."

This view of the Milton depot in the snow of 1910 came from a stereoscope taken by Ellery Burdick. The prominent structure in the center of the photograph is the depot's elevated water tank and windmill. In the background is the Milton House, with its row of second-floor windows peering over the snowbank.

The Milton depot was destroyed by an overnight fire on September 8, 1913. A lightning strike touched off the fire, which reduced the depot to ashes. This view looking west is from an elevated position and shows several people assessing the damage. The office of the former Shemmel Hotel, located across the street and next to the Milton House, was used as a temporary depot.

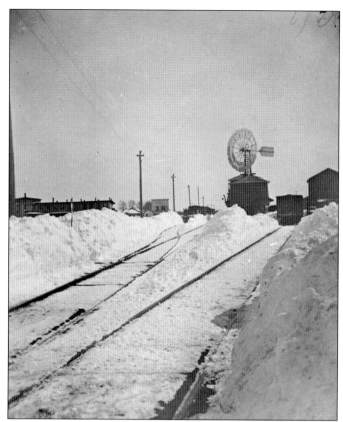

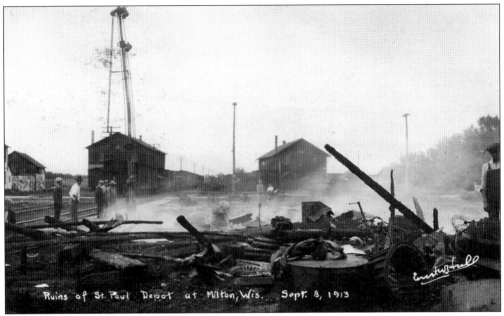

This view looks east over the charred footprint of the Milton depot. In his diary on September 8, 1913, Ezra Goodrich noted, "Lightning struck the depot at Milton and it burned last night. It has been patched up and made over from year one . . . The old depot site looks naked enough. Don't hear anybody say they were sorry it burned."

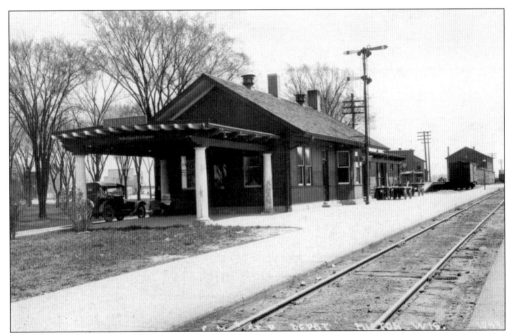

In 1914, a year after fire destroyed the Milton depot, a new facility was completed to continue service for passenger and freight trains. The new depot was constructed on the north side of the tracks adjacent to the park. The building served as a depot until it was abandoned by the railroad in 1958 and given to Milton College, which in turn deeded it to the village.

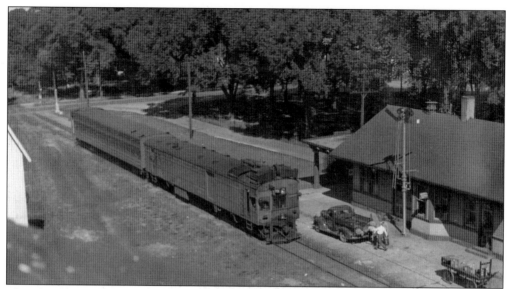

This elevated view of the Milton depot shows the end of an era. The Milwaukee Road passenger service came to an end in the fall of 1951, when this gasoline electric car with one coach made the final run, ending 99 years of passenger train service between Milwaukee and Milton. The depot was abandoned seven years later.

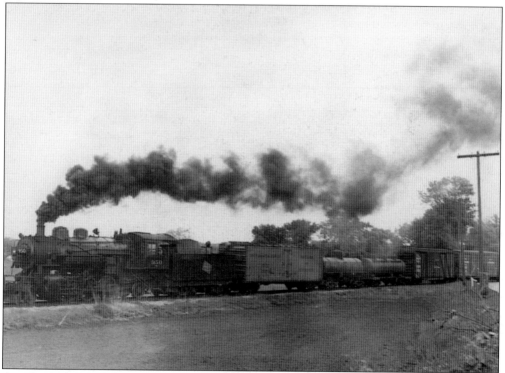

Another Milton rail chapter ended in 1951 when the last Milwaukee-Janesville way-freight passed through Milton. This photograph shows the locomotive steaming southbound between Milton and Janesville. Once this line was discontinued, Milton was served only by a Madison-Janesville and Janesville-Whitewater way-freight on alternate days.

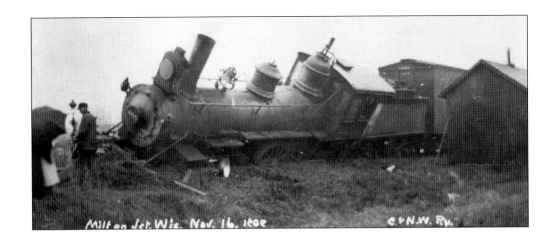

Milton Jct. Wis. Nov. 16. 1908 C & N.W. Ry.

Trains did not always stay upright and on the tracks, as demonstrated by these two images taken from a 1909 postcard. This train ran aground just west of Milton Junction in November 1909. The above photograph shows that Locomotive No. 600 ran off the rails into an embankment and tilted toward the camera. To the left, a couple of people, including a woman shrouded by an umbrella, gather at the front of the engine to survey the damage. The photograph below shows the engine from the opposite side of the tracks and highlights the precarious angle at which the train came to rest.

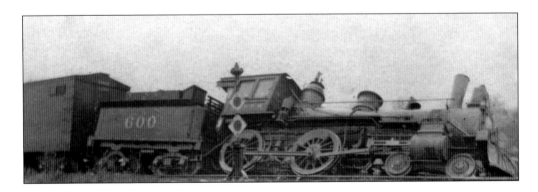

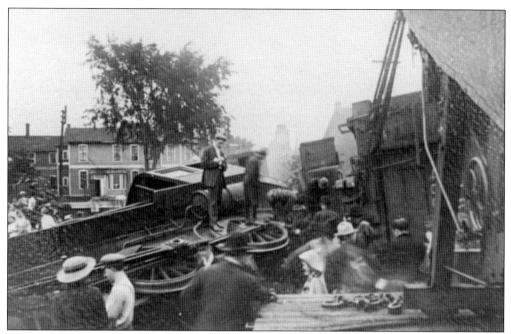

In a wreck within the village limits of Milton Junction in 1907, a crowd of curious onlookers was granted up-close access to this derailment. Men, women, and children can be seen mingling among the wreckage as a man stands on the tipped locomotive taking notes. The Morgan House can be seen in the background.

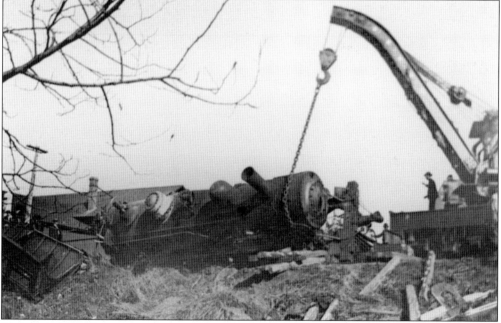

Righting a fallen locomotive was no small task. This photograph of a Milton Junction derailment shows a steam crane latched to a chain as it tries to tilt the locomotive back to an upright position. Lifting a locomotive with the equipment available in the early 1900s was dangerous and difficult work.

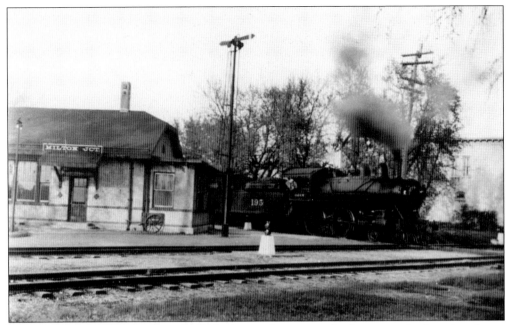

This photograph taken in the early 1930s shows a locomotive backing near the Junction depot. The engineer can be seen as he leans out the locomotive's window to get a better look at his hookup. The view faces east with the Button Building in the background and the locomotive pointing south.

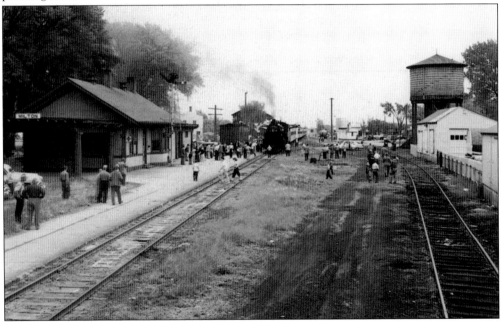

In 1954, three years after passenger service through Milton ended, the National Railway Historical Society sponsored a steam-powered train tour to commemorate the 100th anniversary of passenger service between Milwaukee, Milton, and Madison over the original line of the Milwaukee Road. This photograph shows a crowd gathering to greet the westbound train as it pulled into Milton. The water tower was razed in 1955, and the depot was abandoned in 1958.

Five

MILTON COLLEGE

From the time Joseph Goodrich founded Milton Academy in 1844 until the closure of Milton College in 1982, Milton was one of the few small towns in Southern Wisconsin to be blessed with its own college, offering postsecondary educational options to students from around the corner and around the world. Here are two youngsters looking up at the Milton College sign in the 1950s.

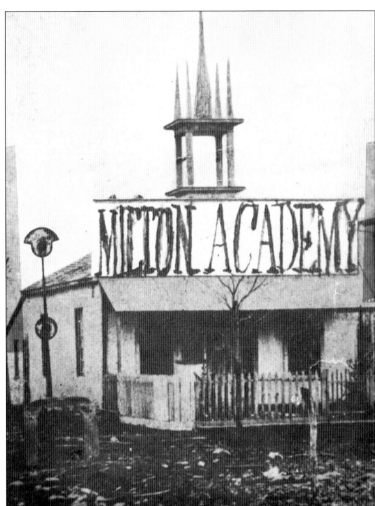

Joseph Goodrich founded Milton Academy in 1844 in this grout building, which faced the park near the location of the Milton House Inn that he was also building at the time. This building soon collapsed, and Goodrich strengthened the grout mixture for his hexagonal inn, which stands today. In 1855, Main Hall was built on the hill overlooking the village, and the school was relocated, chartering as a college in 1867.

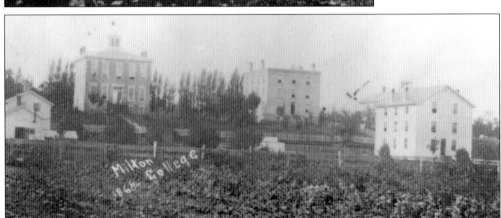

This photograph of the sparse Milton College campus in 1865 was perhaps taken from the upper floor of the Ellery Burdick Photograph Gallery. Main Hall is the building on the left and the second brick building to the right is the women's dormitory, Goodrich Hall. Gents Hall, the male dormitory, is the white wooden structure that was on College Street below the campus hill.

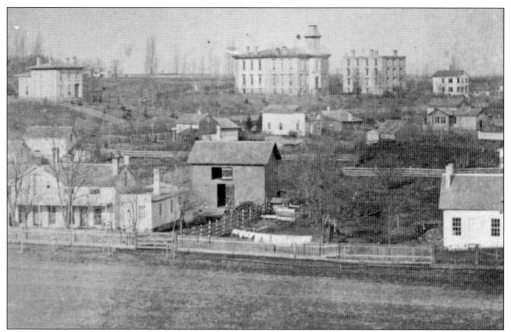

This view of the village and Milton College campus facing west was taken from the roof of the Milton elementary and high school, which was completed in 1869. In 1854, as Main Hall was being built, the school was rechartered as Milton Academy. School president William Whitford—whose private residence is to the left—sought and received a Milton College charter from the Wisconsin legislature in 1867.

This is a view looking north at the rear of Goodrich and Main Halls. The photograph was taken prior to 1900. Main Hall was opened in 1855 after the original academy building became untenable, and classes were held for two years in private residences. An extensive addition to Main Hall was completed in 1867. Goodrich Hall was the second campus building, completed in 1857 as a dormitory for men and women.

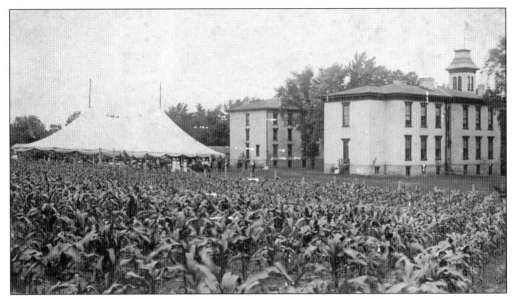

This view over a cornfield shows the Milton College 1898 graduation ceremony. Before the school had a gymnasium or auditorium, a large tent was erected each June to the rear of Main and Goodrich Halls to accommodate the graduation ceremony and other annual scheduled events, such as the school's Shakespearean play.

Main and Goodrich Halls were the symbolic pearls of higher learning in the village of Milton from their perch above College Street when this photograph was taken in the early 1900s. Main Hall remains as a symbol of the college well after the school closed in 1982 as a museum and archives under ownership of the Milton College Preservation Society.

The Rev. William C. Whitford, then pastor of the Milton Seventh Day Baptist Church, assumed the position of principal of Milton Academy in 1858 and served as president of Milton College until his death in 1902. He served for one year in the Wisconsin legislature, four years as state superintendent of public instruction, and nine years as a member of the state board of regents of the normal schools.

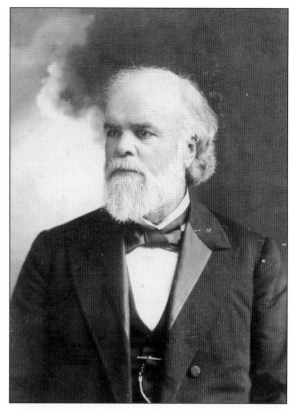

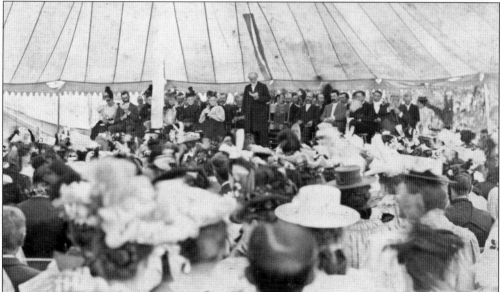

William Whitford addresses the crowd under the graduation tent during the 1898 ceremony on June 29. Much of the growth of the school—from its days as an academy and through the early 1900s as a state-chartered college—can be attributed to Whitford's leadership. A fiery orator and colorful character, Whitford was well respected in academic circles statewide but often feuded with village leaders, including Ezra Goodrich.

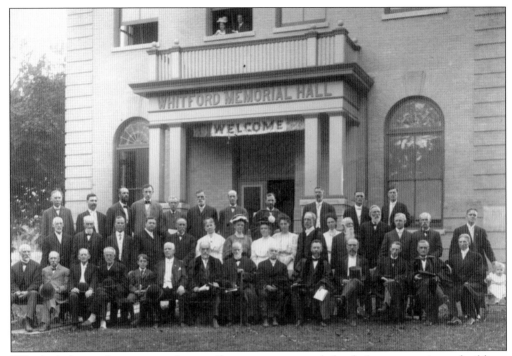

Whitford obtained permission from college trustees to seek funds for a new science building, but his efforts were cut short by his death in May 1902. During commencement exercises that year, it was proposed that a science hall on the spot of the commencement tent would be a fitting memorial to President Whitford. The building was dedicated by the school's faculty at commencement exercises in 1907.

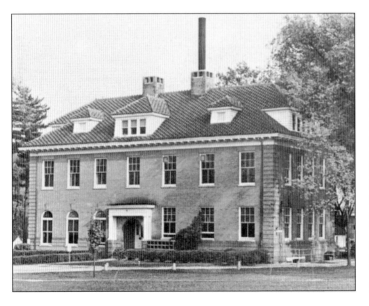

Once Whitford Hall opened for the 1906–1907 academic year, it became the busiest building on campus, as administrators took full advantage of the new space the building provided. The campus library was moved from the Main Hall reading room to the north end of Whitford's first floor. The new hall also housed science labs and other classrooms. This is how Whitford Hall looked in the early 1960s.

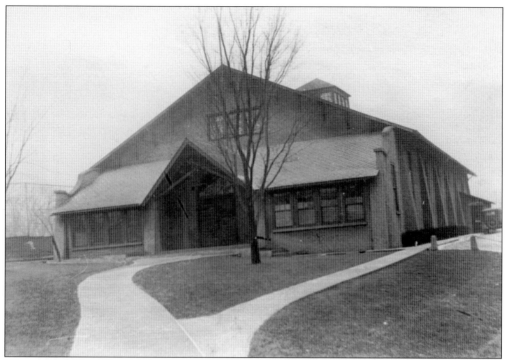

The next addition to campus was a new gymnasium to replace the room in Gents Hall used for athletics. The class of 1909 made a gift of $1,000 toward a gymnasium, an act that soon generated pledges of $8,000 in support of the project. The $22,000 building was finished in June 1911 and served as both gymnasium and auditorium before being remodeled as the Daland Fine Arts Center in 1962.

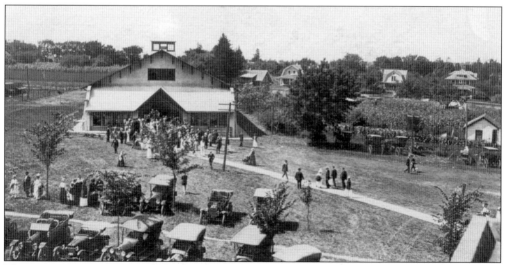

The new gymnasium provided adequate space for athletics as well as other campus functions and gatherings, including graduation ceremonies. This view of a graduation ceremony sometime between 1915 and 1920 shows the east-facing entrance of the building. The photograph was likely taken from one of the upper floors of Whitford Hall.

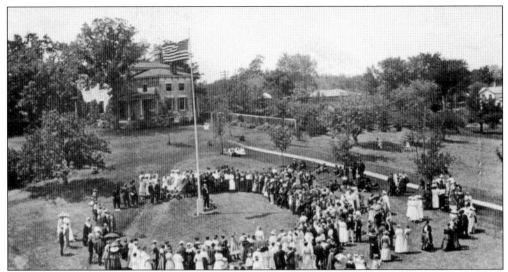

This is a flag-dedication ceremony held on campus during World War I in 1917. The view faces southwest, likely from one of the upper floors of Whitford Hall. The president's home, purchased by the college in 1902, can be seen in the upper left.

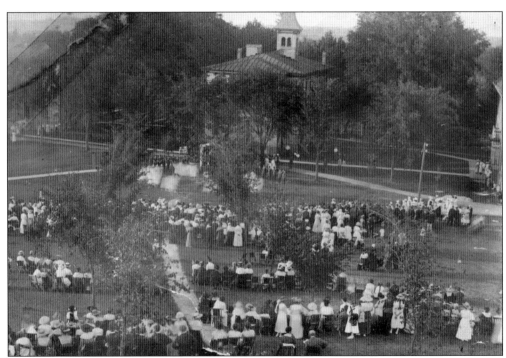

This is a view facing north from the president's house of a 50th-anniversary pageant that was held on the grounds of the Milton College campus during the spring of 1917. Main Hall is in the center background, and the audience seems to be seated in tiers for viewing the pageant. Milton College observed the 50th anniversary of its state charter in 1917.

The preferred and perhaps only non-pedestrian mode of transportation on the Milton College Campus in 1896 was by horse and buggy. These two students, Robert Dykeman (left) and Joseph Granger Brandt, pause to have their photograph taken with their fine horse and carriage along one of the dirt streets of the campus.

Pictured here is a chapel procession led by members of a brass band in the early 1900s. The upper floor of Main Hall housed the campus chapel, and a long line of procession participants can be seen snaking its way down the back steps of the hall and onto the campus grounds.

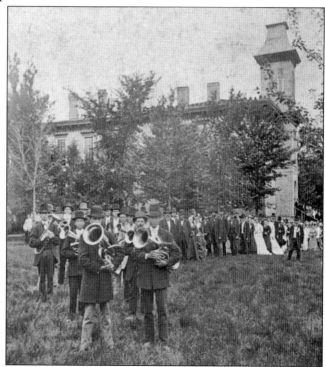

Gents Hall on College Street was an early below-campus wood structure that was built after the Goodrich Hall dormitory so the college did not have to house male and female students in the same dormitory. Part of the building served as a makeshift gymnasium until the new gym was built in 1911.

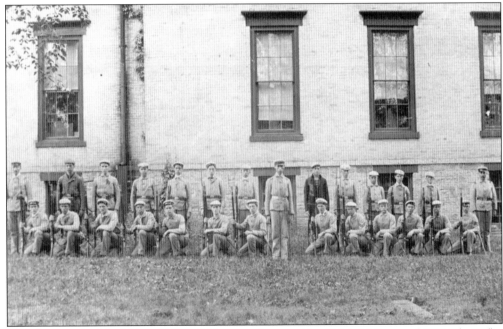

This photograph of the Milton College Rifles was taken outside of Main Hall around 1870. The Rifles were one of many college groups to use the campus grounds to train for military exercises. During the 1860s, the campus was used for drilling by Milton-area Civil War volunteers awaiting official mustering in Janesville. During World War I, military drills were a common site on campus.

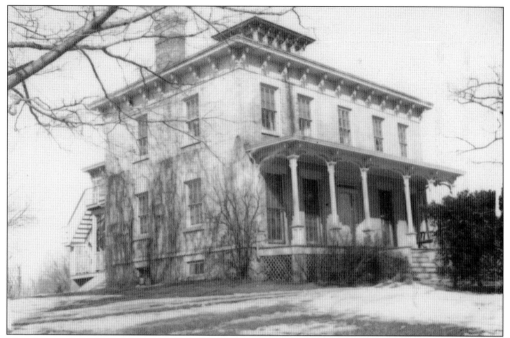

This home facing High Street was purchased in 1902 by Milton College to house Pres. William C. Daland, who followed William Whitford in becoming the college's second president. Daland served as the president of the college until his death in 1921. The home was then remodeled into a music studio until the gymnasium was renovated into the Daland Fine Arts Center in 1962. The home then served as administrative offices.

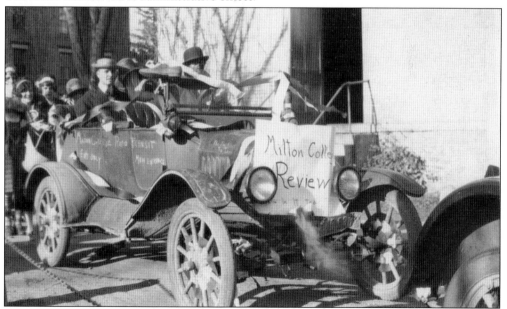

The 1925 Milton College homecoming parade included this entry by the students on the *Milton College Review* newspaper staff. Complete with a driver wearing blackface, the decorated car waited for its turn in the parade from the south side of Main Hall. The Milton grid team won the Wisconsin State Independent College championship that year.

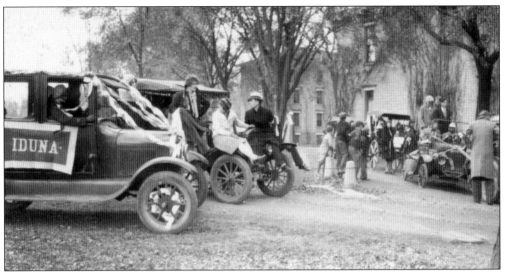

A 1-5 season by the Milton College football team could not dampen the spirits of students in the 1930 homecoming parade. Students brandishing megaphones are poised on the fenders of automobiles or in the open-air tireless jalopy to the right. The parade included an entry from the campus's Iduna Literary Society, at left.

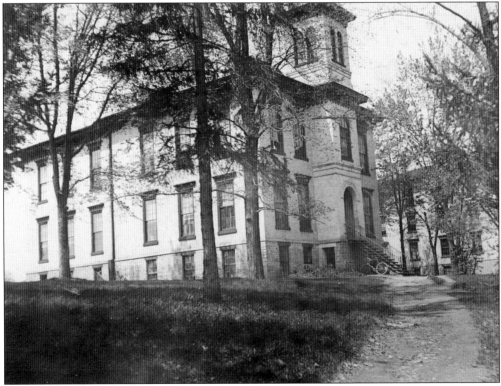

The pathway leading to Main Hall remained dirt and unpaved when this photograph was taken in the 1920s. By this time, the campus had doubled its number of original buildings with the addition of Whitford Hall in 1906 and the gymnasium in 1911. Still, Main Hall remained the center of most campus activity.

The annual All College Days were a staple of campus activities in the 1950s when this tug-of-war match was part of the action. The festivities were organized each year to give students and faculty the opportunity to mingle in an informal and fun environment away from campus. The traditional sophomores-versus-freshmen competitions were organized in an attempt to replace freshmen hazing.

William Zanton was a muddied tug-of-war loser when he shook the hand of a reluctant Milton College president Percy Dunn during the 1955 All College Day event. As president, Dunn oversaw a building boom that revitalized the campus in the late 1950s and into the 1960s. The Dunn Athletic Center bore his name and paved the way for the old gymnasium building to be renovated into the Daland Fine Arts Center.

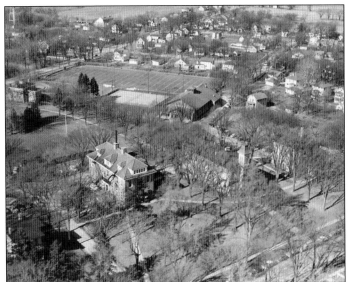

This southwest-facing aerial view of the Milton College campus was snapped from a plane in the mid-1950s. In the foreground is Whitford Hall, with Main and Goodrich Halls obstructed by trees to the right. The athletic field, 20 years after it was constructed in 1935, is the dominant feature in the middle of the photograph, where the Shaw Library was constructed in 1965.

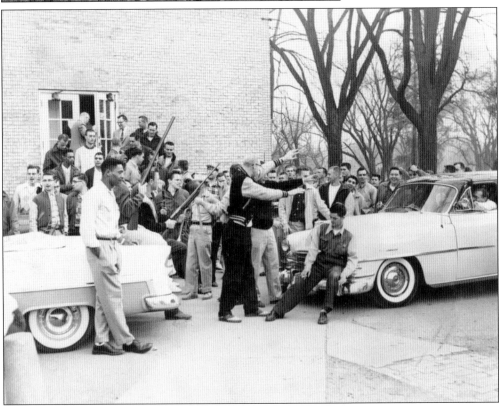

When the 1956 Wildcat football team completed an unbeaten season in 1956, it touched off a campus-wide celebration that cancelled classes. On the Monday following Milton's 26-7 season-ending win against Watertown Northwestern to finish 6-0, students gathered outside of Main Hall for a parade through town that featured honking horns and shotguns as noise-makers. The procession even wound its way through the halls of Milton Union High School, disrupting classes.

From left to right, Prof. Leland Shaw, student Jack Reed, and Prof. Leland Skaggs take part in the annual campus-wide spring cleanup day in the late 1950s. The three are busy at work placing the cement pylons that still border the parking lot to the rear of Whitford and Main Halls.

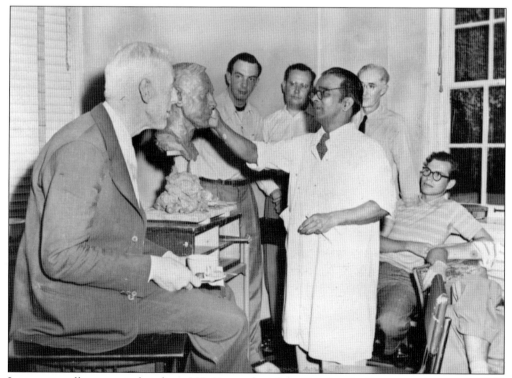

Internationally renowned sculptor V.P. Karmarkar, from Bombay, India, was on campus in 1949 and used dean John N. Daland as a model for this demonstration in the Century Room of Main Hall. Among the interested spectators are professors Bernhardt Westlund and Leland Shaw. The clay model of Dean Daland was fashioned in two hours and displayed in the college library.

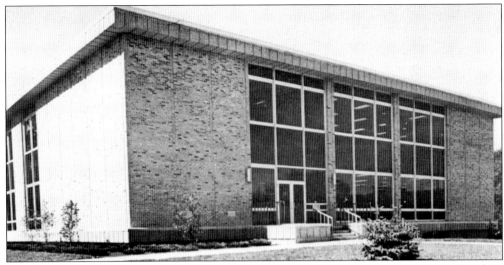

The Shaw Library was at the center of an early 1960s building boom that transformed Milton College. Named for professors Ben and Leland Shaw, the building was completed in 1966 and became the academic heart of the campus. The City of Milton has owned the building since the mid-1980s. Not only has it housed the community's library, the upper floors also hosted city hall and school district administrative offices.

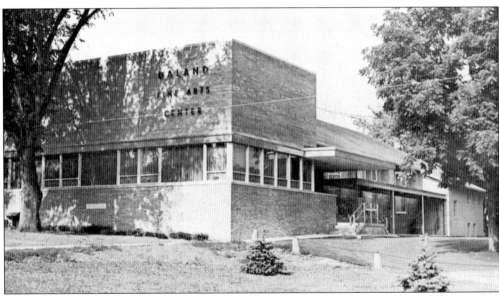

In 1962, the transformation of the college gymnasium was completed, and the Daland Fine Arts Center became the cultural focal point of the campus, housing the school's auditorium along with the theater and music departments. The building's post-college life has included offices for CESA 2 and, most recently, the School District of Milton administrative offices.

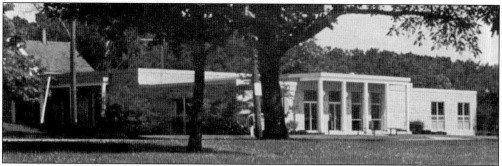

The single-story campus center was built during the mid-1960s at the intersection of Campus Drive and High Street and soon became the new popular student gathering place. The center housed the campus bookstore, food center, and student lounge. Since the college closed in 1982, the building has been home to a variety of businesses and professional offices.

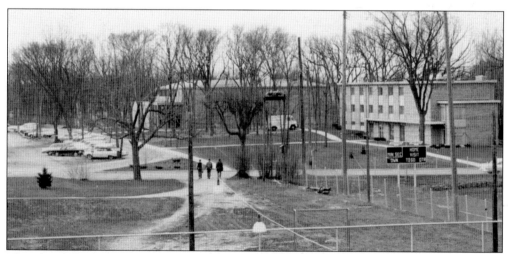

This elevated view looking south shows Burdick Hall women's dormitory to the right and the Dunn Athletic Center in the background. Both buildings were completed by 1960. Burdick Hall became the largest dormitory on campus until Crandall Hall was completed in 1967. The completion of the Dunn Athletic Center paved the way for the renovation of the old gym into the Daland Fine Arts Center.

Twining Hall was one of three similar dormitories built along Campus Drive in the early 1960s. The dorm was named for Nathan Crook Twining, a Civil War veteran who is considered the first graduate of Milton College in 1867. Twining's grandson Gen. Nathan Farragut Twining was on hand for the building's dedication in 1965. General Twining served as chairman of the joint chiefs of staff under Presidents Eisenhower and Kennedy.

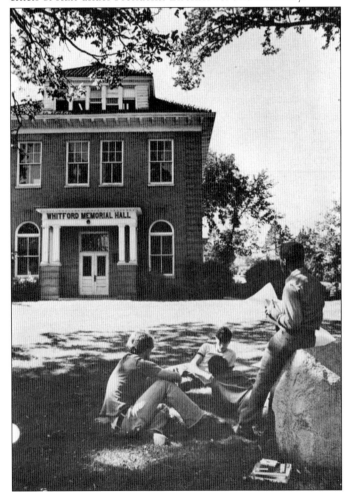

Students are assembled on the north side of Whitford Hall in this photograph taken in the 1960s. Whitford, Main, and Goodrich Halls were each in danger of being razed after the college went bankrupt in 1982. Main Hall is maintained by the Milton College Preservation Society. Fortunately, Whitford and Goodrich Halls were spared when private interests purchased the buildings, and each has housed a variety of businesses in recent years.

Joe Swetish set a tone by bursting through the Wildcat sign prior to the 1965 Milton College homecoming game. It was the final homecoming game at Campus Field. The Shaw Library was constructed on the site, and the football team began playing its games at the new high school field in the 1966 season.

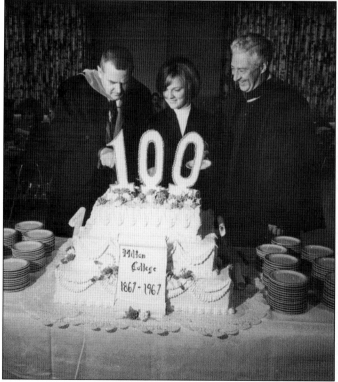

Wisconsin's second-term governor Warren P. Knowles, right, and Milton College president C.W. Banta did the honors of cutting the celebratory three-layer cake during the 1967 commencement festivities when the campus celebrated its 100th anniversary as a state-chartered college. Banta was the ninth of 13 Milton College presidents, succeeding Everet Wallenfeldt in 1965. Banta was followed by Ken Smith in 1968.

This photograph of the five Milton College homecoming queen candidates—along with four male supporters—appeared in the September 26, 1968, *Milwaukee Journal*. From left to right are (first row) Penni Beier (Beaver Dam), Frank Seater (Milwaukee), and Lois Hendricksen (Park Ridge, Illinois); (second row) Michael Lindner (Woodstock, Illinois), Eva Georgouses (Evanston, Illinois), and Lou Cheplak (Wahiawa, Hawaii); (third row) Sue Pennington (Lombard, Illinois), Richard Kreklow (Fort Atkinson), and Sue Ahrensmeyer, (Edgerton).

Prof. Zane Pautz took a class of Milton College students to Germany in 1969 as part of a humanities foreign-studies tour. The travelers included, from left to right, (first row) C.L. Coon and Dr. Pautz; (second row) David Woerpel, Meloyde Hohler, Lynn Paulson, Kathleen Dickinson, and Kurt Wessel; (third row) Linda Cooper and Ann Nelson; (fourth row) Chris Brammer and Sarah Pautz; (fifth row) Joel Winn and Diann Rollins.

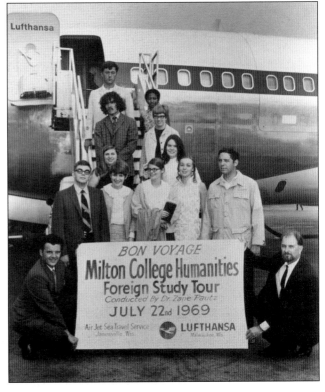

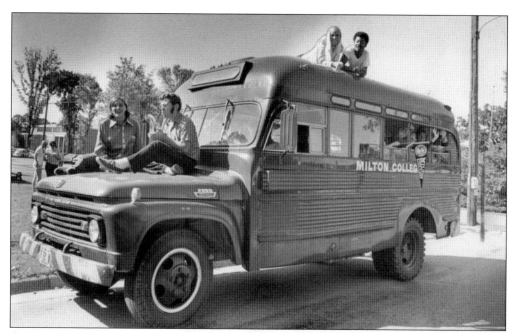

A common site on campus in 1971 was the 20-seat bus named the *Moody Blue*, which shuttled students to and from Janesville as well as off-campus athletic and music events. The bus was purchased by the college for $150 as a surplus vehicle from the Air Force and brought to campus from Camp Douglas near Tomah.

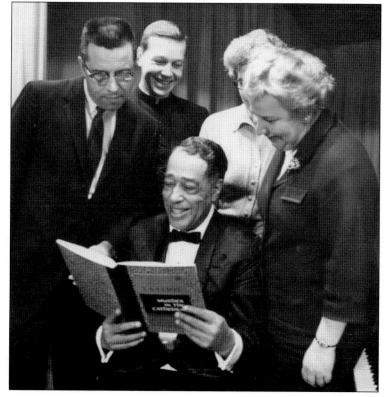

Jazz great Duke Ellington had a special relationship with the Milton College drama faculty. In this 1965 photograph, Ellington is reviewing a score from T.S. Elliot's *Murder in the Cathedral* with Herb Crouch and Ethyl Rich. Ellington and his band performed a well-attended concert at the Daland Fine Arts Center.

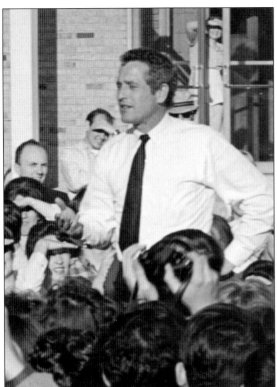

Actor Paul Newman, who was involved with many political causes throughout his career, made a stop on the Milton College campus in 1968 to stump for Democratic presidential candidate Eugene McCarthy. Newman was an outspoken critic of the Vietnam War and claimed that being placed on President Nixon's enemy list was one of his greatest accomplishments. He is shown here addressing a crowd outside of the campus center.

Lew Alcindor, later known as Kareem Abdul-Jabbar, received his first taste of life in the NBA in Milton when in 1970 the Milwaukee Bucks held their preseason camp at Milton College. The Bucks, through their local ownership connections, used the Percy Dunn Athletic Center for two preseasons. The seven-foot-one Alcindor, fresh off a storied career at UCLA, is pictured here as he strolled past the Campus Center.

Dave Krieg became one of the final famous Milton College alums by playing 19 seasons as a quarterback in the National Football League after the college closed. Krieg is shown here shaking the hand of former Wildcat teammate Jim Herbst after leading his Seattle Seahawks to a win over the Green Bay Packers at Milwaukee County Stadium in 1984. Krieg, a Wausau native, quarterbacked the Wildcats from 1976 to 1979.

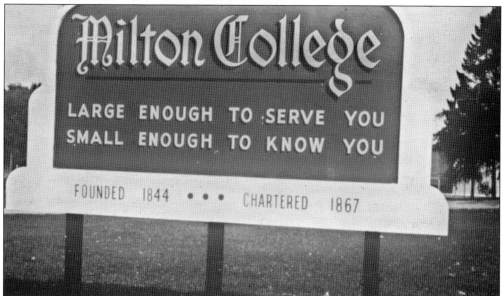

Pictured here is the Milton College sign along High Street as it looked in 1977, five years prior to the closing of the college. Many factors entered into the financial struggles of the school, including a heavy debt burden, a lack of substantial endowments, and a declining enrollment through the late 1970s following a peak of 860 students in 1970.

Discover Thousands of Local History Books
Featuring Millions of Vintage Images

Arcadia Publishing, the leading local history publisher in the United States, is committed to making history accessible and meaningful through publishing books that celebrate and preserve the heritage of America's people and places.

Find more books like this at
www.arcadiapublishing.com

Search for your hometown history, your old stomping grounds, and even your favorite sports team.

Consistent with our mission to preserve history on a local level, this book was printed in South Carolina on American-made paper and manufactured entirely in the United States. Products carrying the accredited Forest Stewardship Council (FSC) label are printed on 100 percent FSC-certified paper.